JAPANESE DRAWINGS

DRAWINGS OF THE MASTERS

JAPANESE DRAWINGS

From the 17th through the 19th Century

Text by J. R. Hillier

LITTLE, BROWN AND COMPANY · BOSTON · TORONTO

A

LIBRARY OF CONGRESS CATALOGING IN PUBLICATION DATA

Hillier, Jack Ronald.
 Japanese drawings, from the 17th through the 19th
century.

 Reprint of the ed. published by Shorewood Publishers,
New York, in series: Drawings of the masters.
 Bibliography: p.
 1. Drawings, Japanese. I. Title.
II. Series: Drawings of the Masters.
[NC351.H55 1975] 741.9′52 75–11513
ISBN 0-316-36394-4

Published simultaneously in Canada
by Little, Brown & Company (Canada) Limited

PRINTED IN THE UNITED STATES OF AMERICA

Contents

ARTISTS AND FIGURES IN TEXT

ARTISTS AND PLATES

JAPANESE DRAWINGS

The drawing, as something distinct from the finished painting, is a concept peculiar to the West—or perhaps we should qualify that by adding "until recent times," since Japan has by now more or less assimilated Western concepts and techniques in art. In the Far East the paintings may be of greater or less elaboration, but they are all paintings—drawn with the same brushes, employing the same ink or color washes; in the West, on the other hand, certain media such as pencil, charcoal, sanguine, and others are used only for drawings and by their nature tend to act as a limit to size. The only near-parallel to Western drawing in Japanese art is the preparatory sketch—the under-drawing or *shita-e*—from, or upon which, an artist would develop his final version for scroll or screen or color print.

Nevertheless, accepting that any division is bound to be an arbitrary and equivocal one, depending on considerations of size and occasion—rather than media and intention which more clearly mark the differentiation in the West—it is still possible to group together a body of Japanese works which we may appraise and enjoy as we would Western drawings. These works are usually impromptu or at least unelaborated, drawn freely from nature or in other ways plainly not intended by the artist for mounting as *kakemono* —though later admirers may have accorded them that mark of respect. In a few instances I have illustrated an artist's work by a *kakemono* where this has the qualities of a drawing and where other drawings have not been available.

The period covered by my choice of illustrations is also quite arbitrary. It would be possible to represent the earliest periods of Japanese art by pressing into service such paintings as the well-known *Bhoddisattva Flying on a Cloud,* drawn in ink on hemp cloth and dating possibly from the eighth century; yet in this remote period the essentially Japanese characteristics have not evolved and it is difficult to distinguish between Chinese works and those of Japanese artists working under Chinese direction. The famous Hōryūji frescoes are claimed for Japan by Yukio Yashiro and for China by Osvald Sirén, and many of the relics treasured in the Shō-sō-in are now conceded to be as likely Chinese as Japanese. It is still more tempting to select effective passages—and they abound—from the Yamato-e scrolls of the eleventh to thirteenth centuries, those wonderful first expressions of the truly national genius for pictorial art, narratives full of incident and drama illustrated by some of the liveliest and most telling drawings in the whole range of Japanese art. Above all, the inclusion of the Kōzanji scrolls of frolicking animals and satirized priests, formerly ascribed to Toba Sōjō, would be imperative. Yet these early scrolls were usually planned to tell a continuous story and spread over many feet, so that they can hardly qualify as drawings even in the loose sense of the word used here. There is, too, a difference between the drawings of such early periods and those of what we call modern times—dating, in Japanese chronology, from about 1600—that is almost the difference between two worlds, and though there are links, and "heredity" often points back to this or that feature of ancient ancestors, it would need volumes far larger than this to illustrate the gradual evolution occurring over the centuries. With a limited number of plates, a selection that extended from the eighth to the twentieth century woud be too heterogeneous, lacking that concinnity which other volumes in this series, notably *French Impressionists* and *20th Century Drawings,* have aimed at and achieved.

There is a considerable body of literature on the history of Japanese painting (a representative selection is included in the Bibliography), and

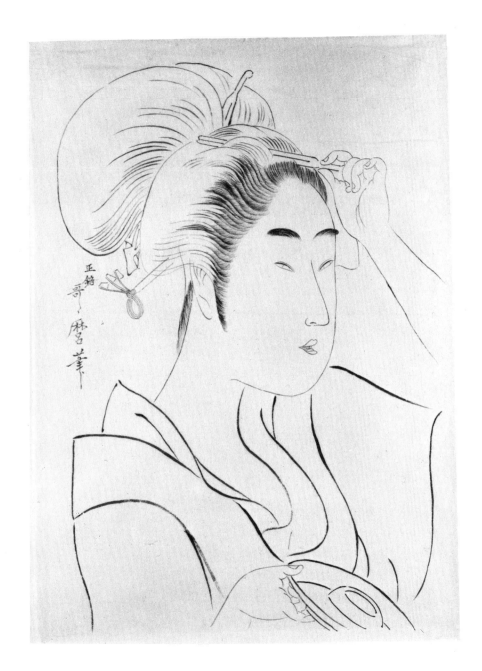

正銘
哥〻
麿筆

Figure 1

Kitagawa UTAMARO
Study for color print, Okubi-e
"Large Head" of courtesan
ink on paper
10⅝ x 14-9/16 inches
Rijksmuseum voor Volkenkunde,
Leiden

no more will be said here than has a bearing on the specific subject of this book. The prime influence from earliest times—from the time of the great Hōryūji frescoes of the seventh century, in fact—was China, but except in rare instances, the Japanese soon assimilated the Chinese styles and produced work that was unmistakably their own; even the paintings of the schools most dependent on China, the Sesshū of the fifteenth century and the Nanga of the eighteenth and nineteenth centuries, are immediately recognizable as Japanese.

The media, however, were identical: the brush, with ink or transparent washes; and the materials, too: either paper or silk. In both countries, great store was set on calligraphy, on the ability to execute the characters of the written language with skill and individuality. It was not simply an expertise, nor a means of communication: it was evidence of a cultured mind. Some, of course, had greater aptitude than others, and often this was the basis of an artist's prowess: the ability to write well. What it implied, too, was a constant seeking for perfection, rigorous practice in forming the correct strokes, and the deliberate cultivation of a manner personal to oneself. The very beginning of an artist's repertoire was a facility in handling brush and ink, and it is this facility which time and again astonishes us in the drawings of the masters. Through the veil of mysticism that may make the subject and the mood of some of these drawings obscure, we can at least respond directly to what we recognize as brilliant brushwork, absolute control which sponsors rather than inhibits an adventurous freedom.

By the seventeenth century, when my selection begins, Japanese painting had a history of almost a thousand years. The two main schools, the Kanō—continuing to draw on the lingering Chinese inspiration, weaker now and rarely replenished from the original source—and the Tosa—which carried on, in a much devitalized way, the old, indigenous Yamato-e style—had both become authoritarian in the manner of aristocracies, imposing their own ordinances and ceremonial and tending to regiment all but the boldest spirits.

Figure 2

Matsumura KEIBUN • *Stems of warabi (bracken)*, c.1820 • ink on paper, 10¾ x 14¾ inches • J. R. Hillier, Redhill, Surrey, England

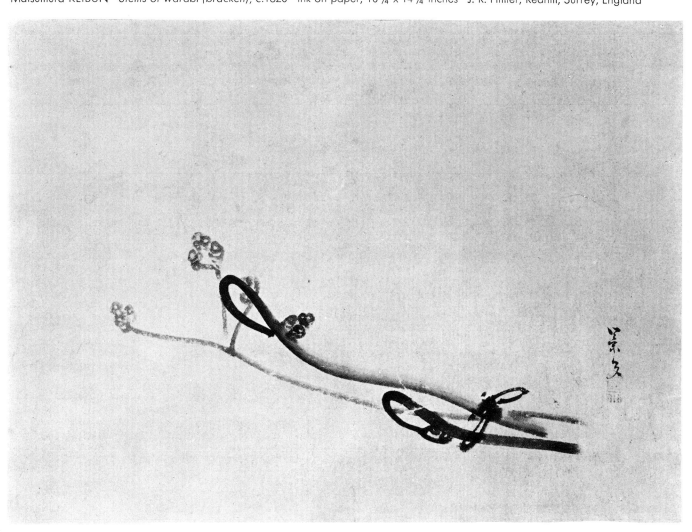

True genius often had to break through the hard crust of tradition and academicism to express itself. The ensuing centuries witnessed a succession of just those struggles with orthodoxy and dogma that we recognize to have been most fruitful of significant art in the West. These departures and apostasies were less obvious than the Western battles of the Romantics, of Turner and Constable, of the Impressionists and their successors, and were without literary champions of the order of Baudelaire, Ruskin, or Zola. Furthermore—and this is of importance in our context—they were usually vented only in works performed for personal friends and kindred spirits: sketchbooks or occasional drawings, the private records of pictorial thoughts which, like the diaries of an author, contain matter hardly intended for public consumption, though in the end they may be all the more precious to posterity as mirroring the innermost mind of the author.

Inevitably, even limiting myself to the period from 1600 onwards, many great names have had to be omitted due to considerations of space or to a lack of accessible works that can be accepted as drawings. Sanraku, Tanyū, and Tōhaku, for example, accounted among the greatest Japanese artists, are not represented.

Among the many misconceptions held in the West about Eastern painting, there is a persistent one that artists did not draw from nature, or *sur le motif*. It is true that sketching from nature was not considered an end in itself, and mere realism, mimicry of nature, was thought of as menial and beneath a great artist. As Conder wrote, "realistic treatment was considered destructive of the primary object of art which was to adorn a surface without destroying the idea of a surface and converting it into an illusion of space." (How modern that sounds for 1911!) Yet, in addition to the evidence of many of the drawings themselves, there is ample corroboration of the importance attached to studies from life. Sōsen, the master painter of animals and especially of monkeys, is reported to have lived in the forest for long periods, the better to study and record monkeys in a natural state. Hiroshige's

diary-sketchbooks allow us to follow him day by day in his tours of the country, when he made the swift topographical sketches on which he later based his designs for a color-print series. Kyōsai, in his *Gaden,* tells of sending his pupils to sketch the living creatures with which he had stocked the grounds of his studio, and adds an anecdote about one industrious youth who had his hair pulled by one of the monkey "models." But Kyōsai also went out of his way to emphasize to his pupils that mere mimicry of nature was not enough: there had to be "correct and powerful manner of execution." Japan has its artist-naturalists, though their exactitude has never won the acclaim there that prowess of that kind has always earned in the West. Nevertheless, such an artist as Nonoyama Kōzan has the gift of Jacques Le Moyne, Moses Harris, and John Curtis, of lifting scientific accuracy onto the plane of true art.

Kōrin is one of the most inimitably Japanese of all the artists of the country. His sense of pattern and his casual adaptation of natural forms and colors result in paintings or designs for lacquer or ceramic that are without parallel outside Japan. Whatever liberties he takes with the form of an animal, bird, or plant, however simplified or modified their shapes may be, the essential character of each remains; indeed, his stylization tends to make his crane the most crane-like of cranes, insisting on its legginess and its serpentine neck; and his pine tree seems the archetype of all ancient pine trees, with twisted bole and leaves and boughs reduced to three or four flattened shapes that are an accepted shorthand for "pine tree." It is, therefore, the more interesting to see, in the pages of a sketchbook, how strongly naturalistic are his studies made directly from nature, or with creature or object fresh in mind. Yet, although refreshingly direct and acute in observation, the drawings betray Kōrin's slant towards stylized patterning: the birds are drawn, from nature, by a hand that is intuitively guiding them to a place in a composition, just as in a wood engraving by Bewick we can sense the artist deciding, perhaps unconsciously, how best the burin would give the effect of plumage.

Kenzan, younger brother of Kōrin, is principally remembered as a potter, and some of his drawings, with their strong, opaque color, their brevity and contained silhouette, remind us of his free drawing on pots, as if he were still conforming to the restrictive shape of teabowl or sake-cup.

Kōrin was much influenced by Sōtatsu, accounted one of the half-dozen greatest of Japanese painters; few of Sōtatsu's drawings—in my limited sense of the word—remain. Nearest, perhaps, are the beautiful hand-scrolls, traditionally ascribed to him and to a brilliant collaborator, Honami Kōetsu; Sōtatsu embellished, with freely drawn animals or plant forms, the decorative poetry inscribed by Kōetsu, an acknowledged master of calligraphy. Even those who do not appreciate calligraphy as a fine art must be impressed by these scrolls as superb works of inspired decorativeness. The drawing of the herd of deer is a perfect example of the ability to simplify and stylize which comes from a complete familiarity with the subject and from an assurance required in reducing the animals and flowers to a few essential lines without robbing them of life or converting them to conventional cyphers. Only by comparing the Sōtatsu/Kōetsu scrolls to something that has elements in common, such as a medieval European illuminated manuscript, can one fully assess their sophistication.

Maruyama Okyō's scroll of naturalistic studies represents something rather different from Kōrin's album. It is the work, almost, of a trained observer, as opposed to that of a weekend naturalist. Okyō, in fact, was a founder of the new school of naturalism in the late eighteenth century that influenced the trend of Japanese painting, or at least one important section of it, for more than a century. This "return to nature" acted as a stimulus to Japanese art, an opening of windows in a room grown airless, a freeing of the creativeness that had been cramped by the stiff uniforms of the established academies. Though hardly seen in that light in the Japan of Okyō's own time, the Maruyama and Shijō schools (the one comprising Okyō's own pupils, the other pupils of his follower Goshun) are seen as the forerunners of a new wave of

Figure 3

Katsukawa SHUNEI • *Head of a drowned woman* • ink on paper • Nathan Chaikin, New York

experimentalism and innovation in the art of painting in Japan, as we see Courbet, Turner, Constable, and the Impressionists in Europe. More subtly, though, the Japanese compare the originator of the movement to Wordsworth, finding an analogy to the change in the spirit of poetry in his time apter than one which has reference to aims in painting so incompatible with their own. The traditionalists who admired the Kanō school style may have missed "the solidity of formal handling and depth of idealistic conception" which inevitably tended to diminish as the outcome of the new naturalism, but by Okyō's time the handling had become too stereotyped and the idealism too forced and jejune to command respect.

Okyō's sketch-scroll leads, then, to the drawings of masters belonging to the schools that were given impetus by his example. These artists, again, did not pursue naturalism to the extreme of realistic mimicry, though unquestionably many of them had the skill to have done so; on the contrary, they restricted themselves to a limited range of flowers, birds, and animals, to still life, to groups of figures not much wider in variety than the staffage figures of the Chinese manuals (though a world away in handling), and to landscapes that were never remotely topographical. Working within the limits of this narrow repertoire of subjects, they gave their mind and skill to the treatment, to the brushwork and composition, so it is not surprising that they should provide a large number of the drawings in this book.

Without the manifestoes and the verbal apologias that heralded and accompanied the West's tardy acceptance of an "art of painting concerned with painting," the Japanese masters performed their drawings for the sheer joy of exhibiting brushwork; they used their flowers and birds, their odd corners of landscape, and their genre scenes without any illustrative intent but simply to provide an occasion for a telling design, to which brushstroke, ink tone, color wash, *mise-en-page*, yes, and paper surface, all contributed. In their drawings we enjoy the interplay of the strong, circumscribing line and the flat silhouettes of the wash, and the skill of the artist is often revealed

by the way he rings the changes on line and mass—as in a concerto where the solo instrument weaves in and out of the orchestra or is, at times, strikingly alone in a cadenza. To the artist, line is an expressive language by which not merely form is denoted, but motion and action, waves and wind, are as forcefully conveyed as Fuji or the strolling peasant. It is a formal language that does not aim at expressing the "spirit of the place," or human mood or emotion, but may of itself create its own spirit, mood, or emotion through the eye of the beholder.

In the paintings of this school we find a greater predominance of *kachō* (bird and flower subjects) than we do in Western art; such subjects are the ideal materials—known and anonymous—for the ploys of these artists. A typical Keibun drawing shows croziers of bracken tied with a piece of string; the subject is only interesting as providing the artist with a means to exhibit his deft brushwork in an arrangement of lines and shapes at once recognizably natural and, in the mental version which follows perception instantaneously, acceptably abstract. We enjoy the best of both worlds, concrete and abstract, as we do in *haiku*. In Chinnen's drawing, for example, we sense the almost miraculous suggestion of the snail's slime and also the contrapuntal note that the shell strikes against the harmony of the bamboo leaves. In Ojū's magnificent drawing of *Two Bulls* (contemporary, by the way, with Goya), we are convinced of the animals' bulk and weight by the great brushstrokes across their flanks; in another corner of our mind we appraise these sweeping tracks of the wide brush as having a separate formal existence, just as we would a pattern of wheel marks in sand. Even in Nanrei's lively monkey-trainer group, which cannot but remind us of Toulouse-Lautrec, we are conscious not merely of the humor of the scene, but also of the gaiety of the color and the bravura of the brush, both contributory to that humor but with a separate existence on another, non-representational level. Zeshin is another of the great artists of this school: few artists have shown such complete command of the brush and so fresh and inventive an approach to subject and composi-

tion. Among all the delightful drawings, East and West, of girls washing their hair, Zeshin's is unsurpassable. He was one of the finest lacquerers of all time, and it is not surprising that he should occasionally have produced drawings in this unusual medium on a scale larger than that permitted by the *inrō* and similar small utensils. Zeshin's *Gourd* is a startling composition in which he has used the texture and mineral glint of the medium to add a new dimension.

The dependence of Japan upon China in the arts is an acknowledged fact, though it tends to be exaggerated to the extent of denying to Japan its own original contribution to the art of the world. Maspéro was not overstating the case when he wrote, "The Japanese are the only people of the Far East with whom Chinese culture has become naturalised so completely as to have given rise to an original art." Nevertheless, there has always been one side of Japanese painting that has continued to show a pronounced leaning and deference towards China. From the earliest times, paintings of the Chinese masters were revered and collected, and were made available in woodcut reproduction to a wide public; Chinese painters visited Japan and introduced Japanese artists to Chinese methods and styles at first hand; manuals of instruction, such as the famous *Mustard Seed Garden* which first appeared in Japanese in 1748 and went through many editions, make it plain that there was a genuine interest in Chinese painting among the literate public as well as the practicing artists.

In the eighteenth and nineteenth centuries, the artists of the Chinese persuasion can be classified as we would the adherents to a political creed. On the far left are the *Nanga* and *Bunjinga* groups, completely indoctrinated extremists who at times out-Herod Herod and even parody their exemplars. *Nanga* and *Bunjinga* are both terms that originated in China; the term *Nanga* relates to the "southern" school of China, supposedly freer in style and more spiritual in content than the opposing "northern" school; *Bunjinga*, "literary man's painting," alludes to the personal, intellectualized approach to

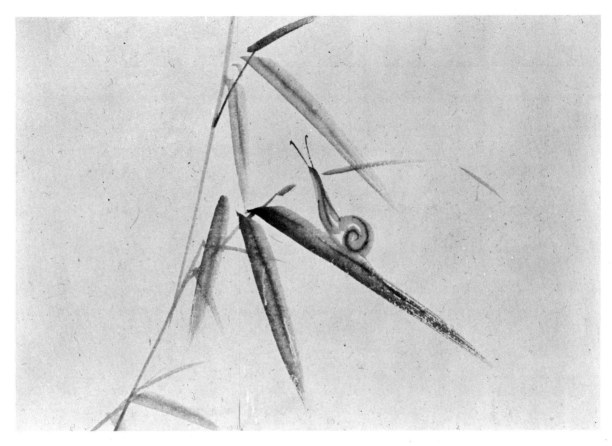

Figure 4

Onishi CHINNEN • *Snail on bamboo* (section from a *makimono*), 1838 • ink and color on paper, 11¼ inches high • J. R. Hillier, Redhill, Surrey, England

painting of those who were scholars and poets first and painters secondarily. Because of the prejudice against their often non-representational painting in the days when the West first began to turn to Far Eastern painting— Fenollosa inveighed against *Bunjinga* with all the intolerance of a believer denouncing atheism—the work of these artists is still little appreciated outside Japan, and most of the finest examples of their work remain there.

The passages from the superb scroll by Hyakusen are the work of one who was a master in his own right, though he is often mentioned only because of his influence on Taiga and Buson, who are possibly the greatest exponents of this type of Japanese painting. Morrison, writing in 1909, felt it necessary to warn students that "whoever wishes to enter on a comprehension of *bunjinga* by gentle stages should not begin with Taigado"; but by now, when we approach him with the understanding that comes of witnessing irrationality in all its forms, from Dadaism to Tachism, he seems quite healthily zany. Hankō exploits the lateral-dot technique of the Sung master Mi Fei and produces a result as bizarre to us as pointillism must have seemed to French traditionalists. Gyokudō, working within the conventional *Nanga* repertoire of subjects and techniques—the spare, spiky trees, the impossible peaks, the huts of the literati, the characterless staffage figures (all could be learned by the tyro from the *Mustard Seed Garden* and other instructional manuals)—composed some of the most personal and emotive landscapes in all Japanese art, with qualities that make their impact immediately on anyone sensitive to pictorial values. Here is a use of line and roughly applied wash— mostly ink but sometimes with a rusty color that gives a melancholy harmony with the lovely greys of the ink—that reaches those depths in us that are touched by the roughed-out marble of Michelangelo's self-portrait, the scrannel notes of a violin, the break in a human voice: all those daring and deliberate intimations of failure which, from a master, have a poignancy not to be found in perfection.

At the center of the *Nanga* movement we have artists less obviously

committed to extremism, Tani Bunchō, Kazan, Chinzan, Bai-itsu, for example, all of whom display a wider compass and, in Bunchō's case especially, an eclecticism that precludes any idea of rigid adherence to China. Kazan is particularly apposite in the context of a book on Japanese *drawings* since he regularly followed a practice of preparing sketches for his more important paintings; one of his Japanese admirers, Fujimori Seikichi, roundly declared in one instance that "his sketch is freer and has more scope, and the strokes are also more distinguished" compared with the finished painting. In the preparatory sketch for the portrait of Sato Issai (one of many preliminary drawings for this painting), Kazan is feeling his way towards that very realism which, in his letters to his pupil Chinzan, he inveighed against. "So-called realistic accuracy is to be avoided," he wrote, "exact reproduction falls into vulgarity." It is remarkable among Japanese drawings of the period, and yet in some ways amounts almost to a betrayal, an early example of that ill-conceived submission to the West which had so disastrous an effect on the native genius in painting from the Meiji era onwards.

In some of the drawings of the *Nanga* school—those of Bai-itsu are good examples—we encounter the "boneless" style, one of the techniques that were almost the prerogative of the Chinese school and a feature that helps to distinguish drawings of the school from those of say Shijō and Maruyama, where the brush outline invariably remains an integral part of the style. Yet the *Camels* of Chinzan, one of the most delightful drawings of the period, shows how difficult and unnecessary it is to draw distinctions between the different schools of Japanese painting during the nineteenth century: the "sentiment" of this sketch, where the humor lies in the treatment, is entirely "Shijō."

Bumpō represents better than anyone else the Chinese-of-the-right, and at times he is almost indistinguishable from his Shijō and Maruyama contemporaries with whom, indeed, he occasionally collaborated: there seems to have been perfect harmony between members of all the "classical" schools,

and the printed anthologies of the time were supplied by artists of all denominations, even Ukiyo-schoolmen occasionally joining their company.

Hanabusa Itchō might be looked on as a link between Kanō and Ukiyo-e —he employed the assured and manneristic brushwork of the Kanō to depict lively genre scenes of the "Floating World"—and his brand of rumbustious humor harks back to the Kōzanji scrolls as well as forward to Kawanabe Kyōsai. He was essentially a draughtsman, with the deftness of touch and nice sense of harmonious, limpid color that override mere school classifications. Masayoshi is another of those who bridge the popular and the classical schools, although his first training was under an Ukiyo-e master. He is the born experimenter, revelling in his mastery, exploiting with a drollery few could match that epigrammatic, caricatural method known as *ryaku-ga*.

But Ukiyo-e, as the school purveying "art for the masses," was popular and vulgar, and employed techniques that showed no reverence for classicism. Although we know it best by the lovely color prints of courtesans and actors, genre scenes in the pleasure-quarters of Edo, and the landscapes of Hokusai and Hiroshige, most of the print designers were painters. They normally worked in body color, their paintings thus having an opaque solidity which immediately separates them from the ink-and-wash paintings of other schools and from the definition of "drawing" on which my selection is based. But there are two types of Ukiyo drawing on which I have freely drawn: the *shita-e* or preparatory sketch for a color print; and the occasional brush drawing produced *con amore,* or even on special commission, by later artists, especially Hokusai, an artist whose gifts as an outstanding draughtsman seem to have been appreciated even in his own day.

Shita-e were rarely preserved. More often than not they were destroyed in the block-cutting process; even when they were spared the knife (a copy having been made for the block cutter's use), they were so little thought of that they were either thrown away or else used as scrap paper. The fine Kiyonaga drawing in the British Museum, a first draft for a well-known print, was rescued from the binding of an album.

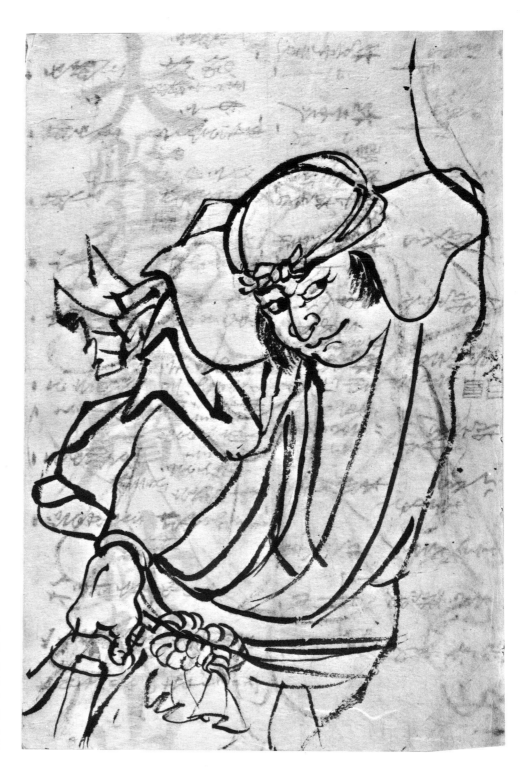

Figure 5
Kuniyoshi Pupil
Warrior holding sword in his
right hand, c.1850
ink on paper
9⅝ x 13 inches
The Ashmolean Museum,
Oxford

Some of the Kuniyoshi sketches are in the nature of first probes, reconnaissances in a search for the firm outlines of a woodcut—already in the artist's mind but needing confirmation on paper; others are fully completed and colored (like the *Kashiwade* in the Victoria and Albert Museum), perhaps elaborated specially for a patron who admired a particular print. The Utamaro outline, looked at simply for its brushwork, is not impressive, but its limited aim of guiding the block cutter should be borne in mind: the commanding sense of design is hardly less evident than in the finished color print.

With Hokusai and Hiroshige, both nominally of the Ukiyo-e school, we are concerned with drawings that are not strictly classifiable as Ukiyo-e at all. Preliminary designs for woodcuts by both artists exist (some of Hiroshige's are illustrated in this volume), but the drawings most impressive to us have no connection with prints. Throughout his immensely long career, Hokusai was continually evolving new and personal styles that resulted in some drawings that are, to us, among the most immediately appealing of all Oriental drawings. Hiroshige, simply following his own artistic sympathies (he seems to have had no regular training outside the Ukiyo-e circle), produced his own version of Shijō in figure, landscape, and *kachō*. Hokusai is a compendium of styles, obeying no rules, defying all canons, but occasionally overwhelming us by sheer painterly mastery. Hiroshige is more limited: he is merely human where the other is a prodigy; but as a landscapist especially, he has an inti- as we do to David Cox or Winslow Homer.

Other Ukiyo-e artists occasionally went beyond the bounds of the accepted style of the school. The daring *haiga* of Kunisada—normally one of the most prosaic of artists—brings me to other spheres of Japanese drawing not so far touched upon. Almost every man of taste in Japan was a versifier, and nearly everyone who could write a stylish character was an artist: there was possibly more amateur verse and painting in the Japan of the Edo period

Figure 6

Kawanabe KYOSAI • *Customs office at Yokohama* • ink on paper, 10-7/16 x 14-13/16 inches •
Rijksmuseum voor Volkenkunde, Leiden

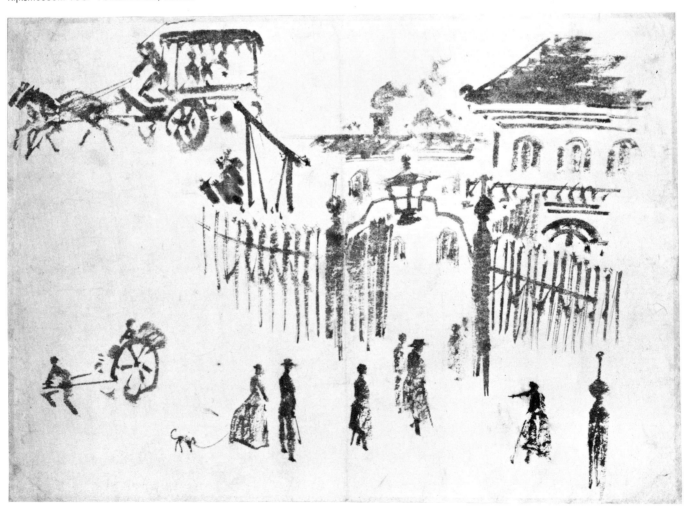

than in the rest of the world put together. With this double talent, poets found it unnecessary to restrict themselves to the calligraphy of their verse; an irresistible and otherwise inexpressible poetic urge often led them to overspill, as it were, from the verse into the margin, with drawings both decorative and interpretive. (Hence *haiga,* from *haiku,* the verse, and *ga,* the drawing.) The *Butterfly and lattice-window* drawing obviously carries on a poetic train of thought, and also repeats the spidery scrawl of the calligraphy. Kunisada's *haiga* is even more sophisticated; the wild and whirling figure of a famous Kabuki performer is almost miraculously prescient of Expressionism.

Zenga, drawings inspired by the Zen cult of Buddhism, carry us still further into a recondite, metaphysical world. They are the work of religious fanatics who expressed themselves in drawings from which every artifice has been stripped, drawings of the subconscious or of intellects entranced, naively childlike but with distortions only an adult mind could impose. With an artist like Hakuin, a completely dedicated priest, incompetence is a virtue, and clumsiness rather than grace is his aim; the result is as painfully shocking as the blow that the Zen priest aims, inexplicably and without warning, at his blameless acolyte.

The drawings of Kyōsai bring us almost to modern times, to a period when European influences were first freely admitted to Japan. At times, one almost feels that Kyōsai is painting with one eye on the admiring foreigner, out to astound by his virtuosity (firsthand accounts of foreign visitors prove that this is far from fanciful) ; in any case, many of his drawings do exhibit a superb mastery—they are vivacious, droll, exuberant. He is one of the great exponents of diablerie, for which Japanese artists have often shown a weakness, pursuing the grotesque, the macabre, and the ghostly with all the inexhaustible extravagance of Bosch or the Bibienas. But at his greatest—in the strangely presentimental *Customs House at Yokohama,* with the intimacy of

the *Nabis* and the everyday eventfulness of T. S. Lowry; or in the splendidly expressionistic *Falling Postman*—Kyōsai assumes the stature of an artist of the world, not merely of Japan.

Such a statement as the foregoing is the result of an almost ineradicable habit of making mental comparisons with Western art whenever we look at an Oriental painting or drawing. However much we would like to support what Yukio Yashiro advocated in his introduction to *2000 Years of Japanese Art*—that is, to look at Japanese drawings simply as drawings, breaking the custom of regarding Japanese art as the exclusive domain of specialists—there is a temptation, an unconscious bias, in making a selection such as this to select just those drawings most likely to appeal to us in the Western world today. A Japanese, consulting only traditional Japanese taste, would unquestionably have chosen no more than half of the drawings represented here, and would have included many that would probably make little impact upon us. Nevertheless, our artistic sympathies, like theirs, are continually broadening, and this anthology spans a gamut of Japanese styles that would have had too wide a compass for most Western art lovers even fifty years ago. In another fifty years, perhaps, the respective selections by Japanese and Westerner might well more nearly coincide.

<div style="text-align: right">J. R. HILLIER</div>

Plates

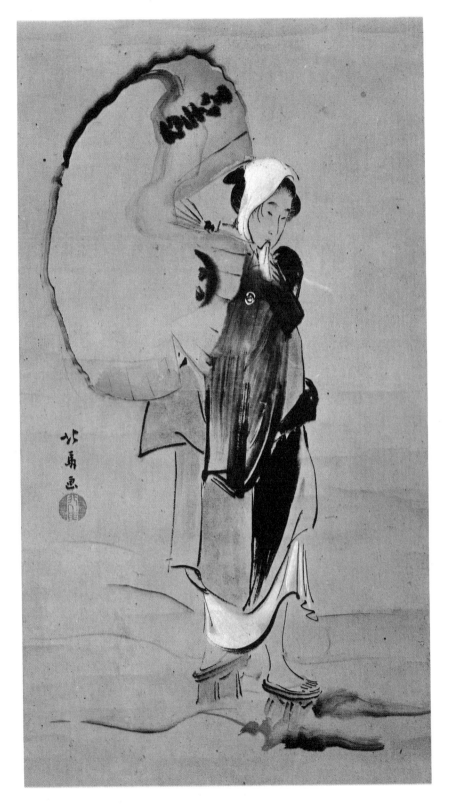

Plate 1

Teisai HOKUBA
Girl with torn umbrella
ink and slight color on paper
Ralph Harari, London

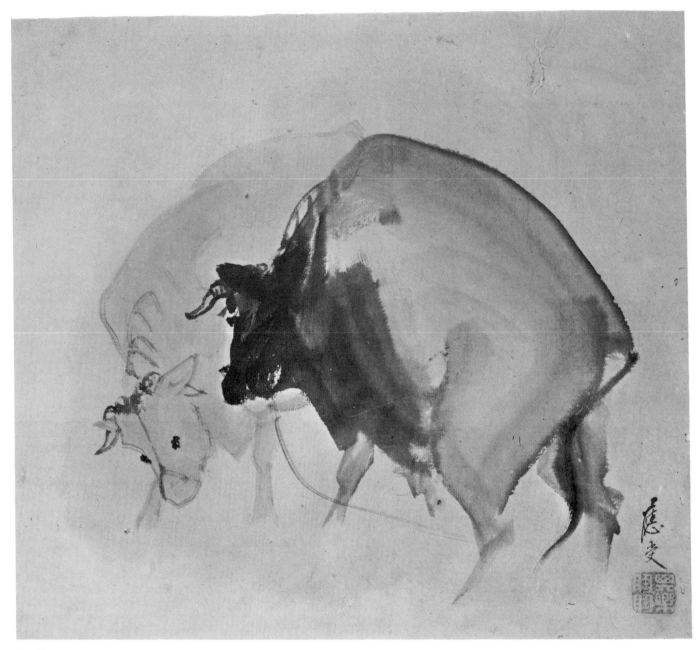

Plate 2

Maruyama OJU · *Two bulls,* c. 1800 · ink and color on paper, 11½ x 12¾ inches · J. R. Hillier, Redhill, Surrey, England

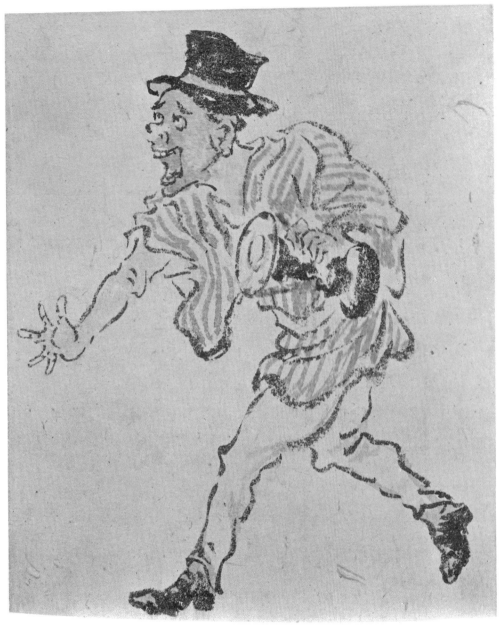

Plate 3

Kawanabe KYOSAI • *Man in European hat running with tsutsumi* • ink and color on paper, 6-11/16 x 5-5/16 inches • Rijksmuseum voor Volkenkunde, Leiden

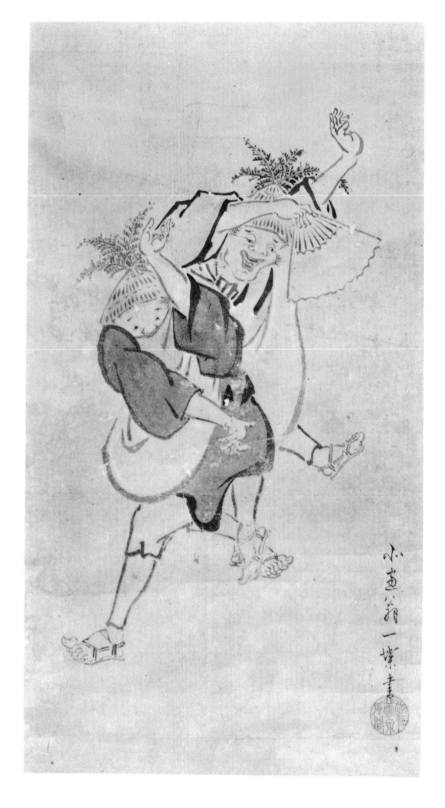

Plate 4

Hanabusa ITCHO
Two men dancing
color on paper,
37¼ x 11¼ inches
British Museum, London

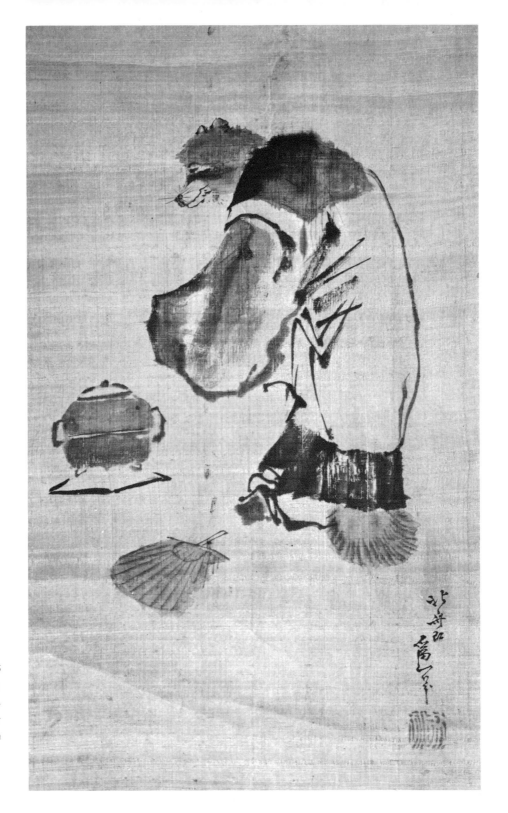

Plate 5
Katsushika HOKUSAI
Badger and kettle
ink on paper
Ralph Harari, London

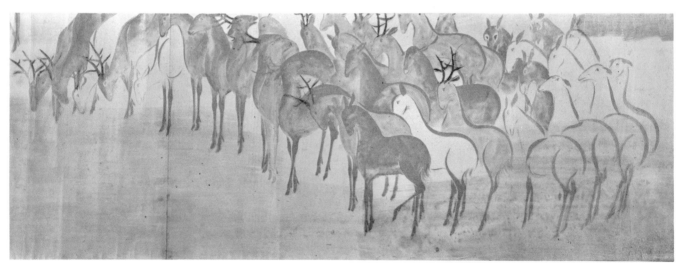

Plate 6

Nonomura SOTATSU • *Section of the "Deer Scroll"* (Calligrapher, Honnami Kōetsu) • Late Momoyama or early Edo period • ink, gold, and silver on paper, 12½ inches high • Seattle Art Museum, Washington, gift of the late Mrs. Donald E. Frederick

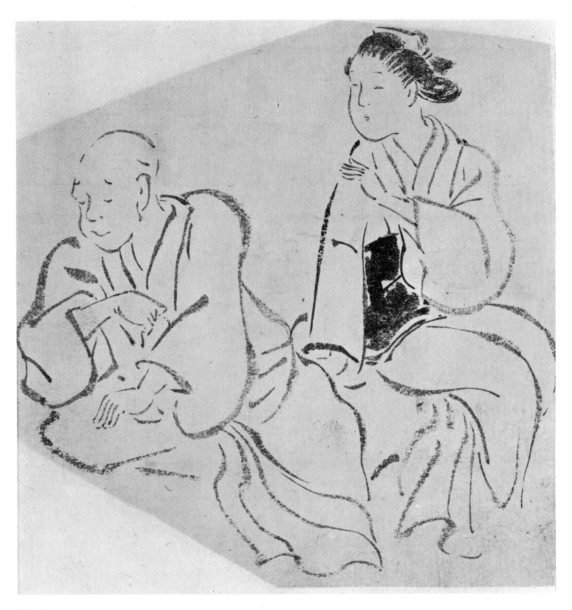

Plate 7

Hanabusa ITCHO · *An unresponsive guest—a girl attempting to engage a coy man in conversation* (study from a *makimono*) · sumi on paper, 5⅞ x 6 inches · Mme. Janette Ostier, Paris

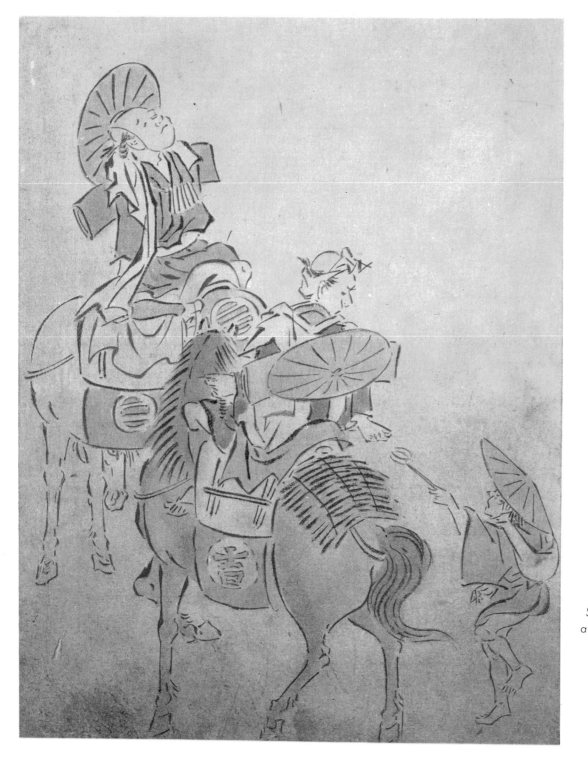

Plate 8

Hanabusa ITCHO
*Two travellers on horses, one
giving alms to a beggar boy*
ink and color on paper,
10¾ x 9⅝ inches
Mme. Janette Ostier, Paris

Plate 9

Hanabusa ITCHO
*Samurai walking, followed by
a servant with bag on his back
and drum in his hand*
ink and color on paper,
10¾ x 10⅝ inches
Mme. Janette Ostier, Paris

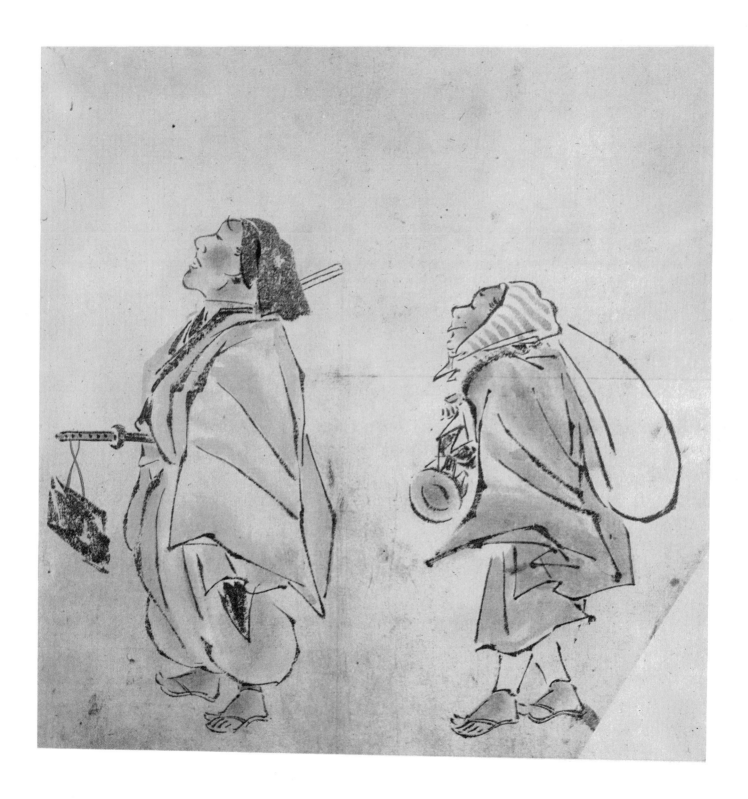

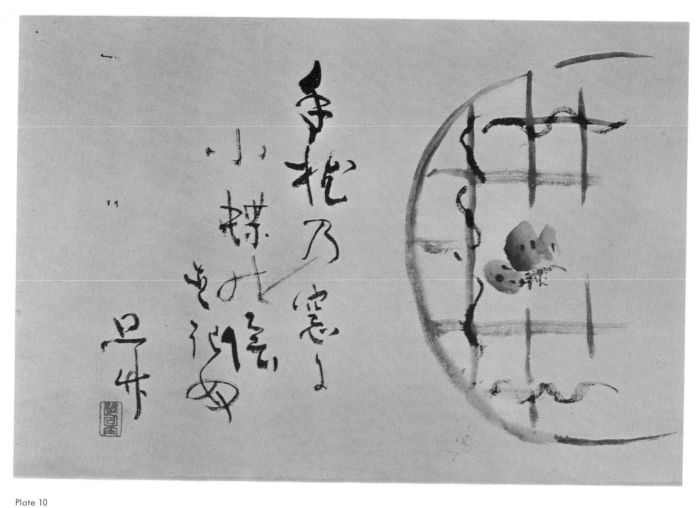

Plate 10

SHICHIKU · *Butterfly at a lattice window* (Haiga), 1827 · ink on paper, 12 x 19½ inches · J. R. Hillier, Redhill, Surrey, England

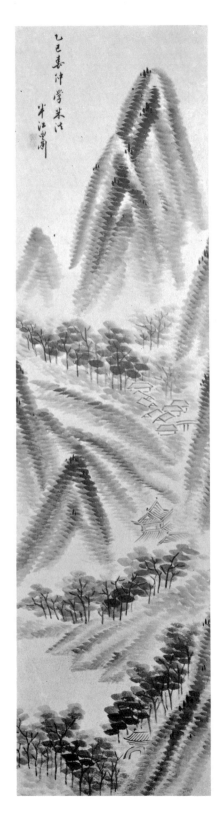

Plate 11

Okada HANKO
Landscape in the Chinese manner, 1845
ink and a little color on paper,
50¼ x 13¾ inches
J. R. Hillier, Redhill, Surrey, England

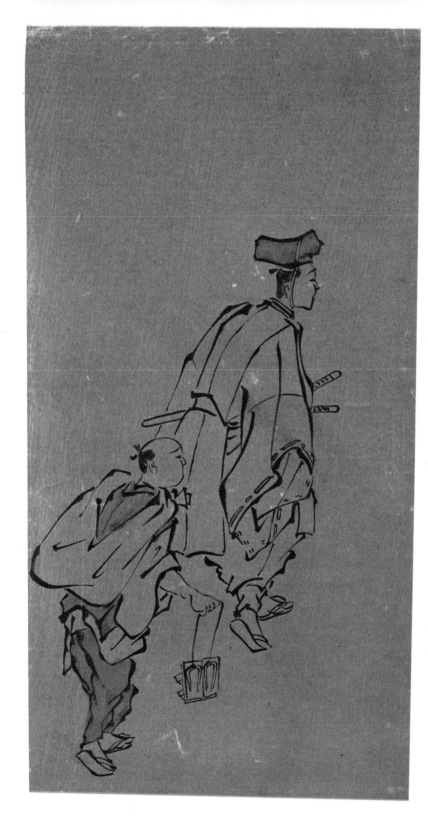

Plate 12

Totoya HOKKEI
Nobleman and attendant
ink on red paper,
10⅛ x 5⅛ inches
Rijksmuseum voor Volkenkunde,
Leiden

Plate 13

Sakaki HYAKUSEN • *Monkey-trainer* (section from a *makimono*) • colors on paper, 11 inches high • Ralph Harari, London

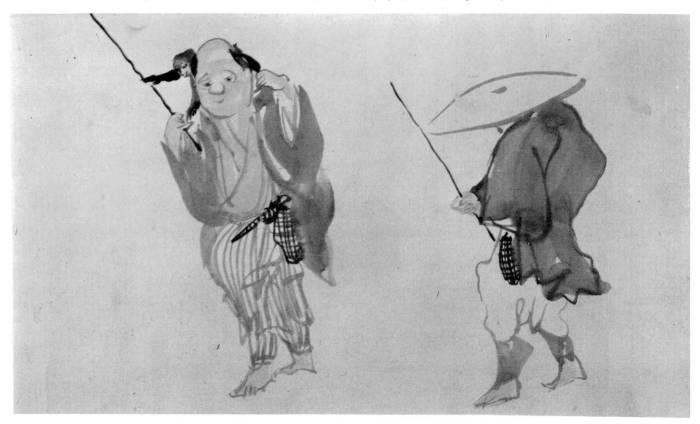

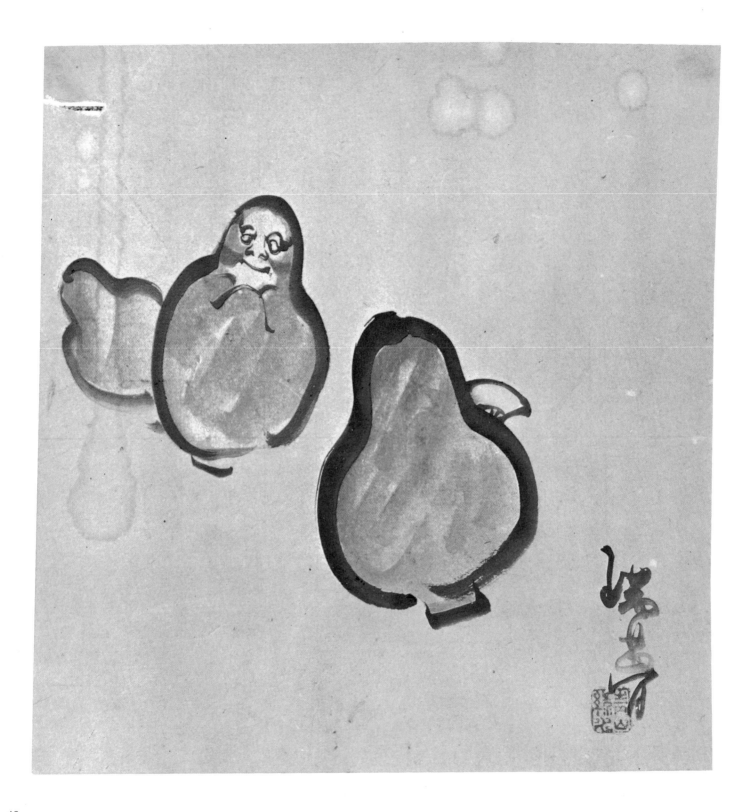

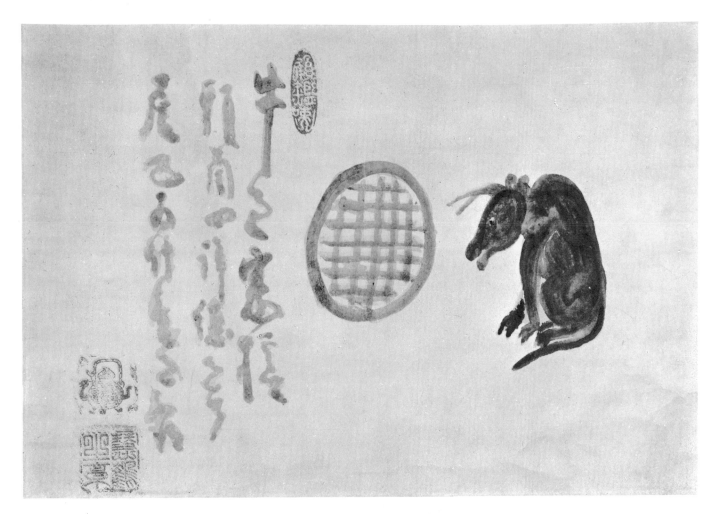

Plate 15

Ekaku HAKUIN • *Cow by an oval window (study from a makimono)* • ink on paper, 10¾ x 14¾ inches • Mme. Janette Ostier, Paris

Plate 14

TOMMU
Daruma Dolls
ink and color on paper,
11⅛ x 10⅞ inches
J. R. Hillier, Redhill, Surrey, England

Plate 16

Sakaki HYAKUSEN • *Two noblemen seated together* (section from a *makimono*) • colors on paper, 11 inches high •
Ralph Harari, London

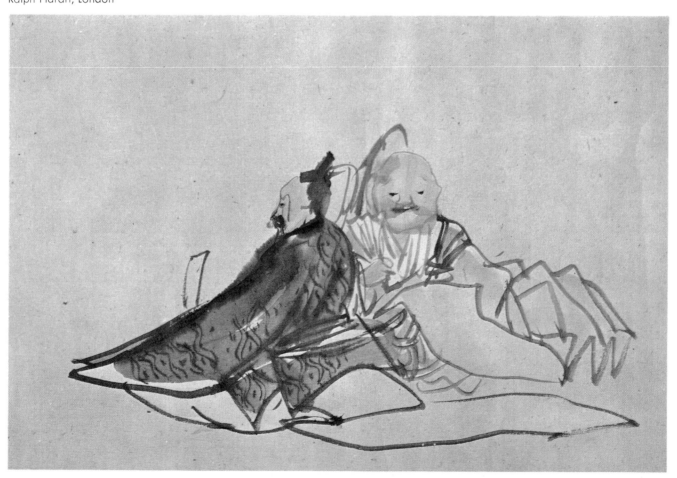

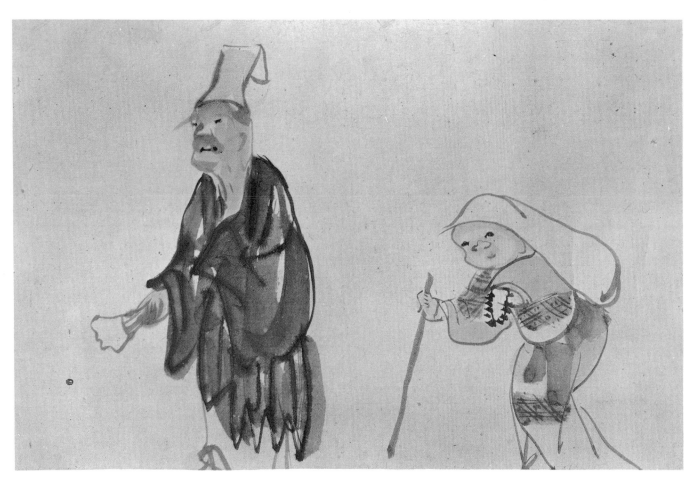

Plate 17

Sakaki HYAKUSEN • *Priest and girl with rosary (section from a makimono)* • colors on paper, 11 inches high • Ralph Harari, London

Plate 18

Ichiyūsai KUNIYOSHI • *Sketch for book illustration* • ink on paper, 7½ x 10-7/16 inches • Rijksmuseum voor Volkenkunde, Leiden

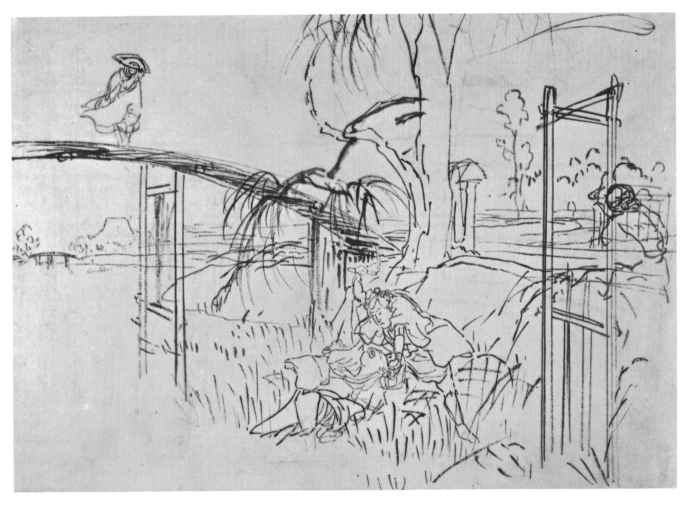

Plate 19

Ichiyūsai KUNIYOSHI • *Yoemon murdering his deformed wife with a sickle* • ink on paper, 9⅝ x 13-9/16 inches • Rijksmuseum voor Volkenkunde, Leiden

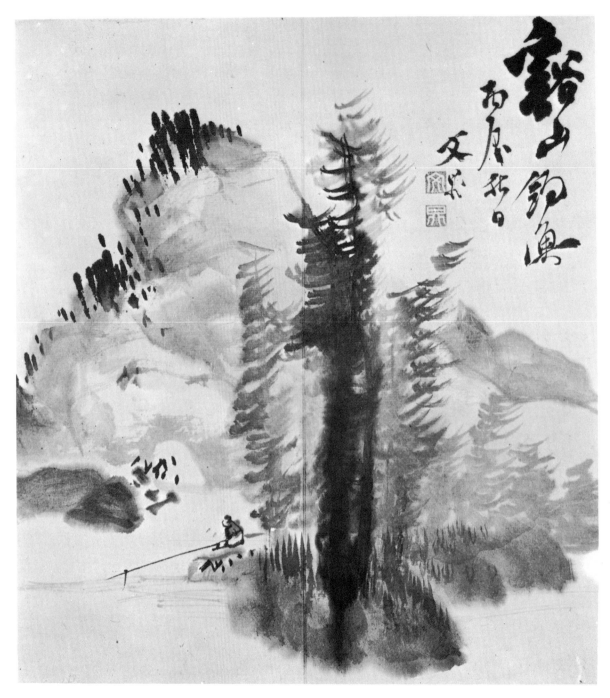

Plate 20

Tani BUNCHO · *Landscape with angler* (from an album) · ink on paper, 9-13/16 x 10-15/16 inches ·
British Museum, London

Plate 21

Ogata KORIN • *"Isle of the Blest"* • ink and color on paper, 19-5/16 x 14-3/16 inches • British Museum, London

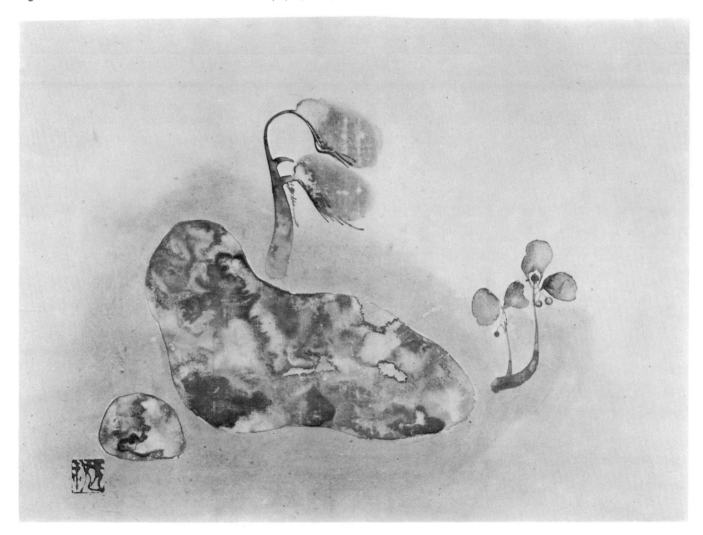

Plate 22

Maruyama OKYO · *Puppies playing*, 1779 · ink and slight color on silk, 15½ x 20¾ inches · Mr. and Mrs. P. Gale, Mound, Minnesota

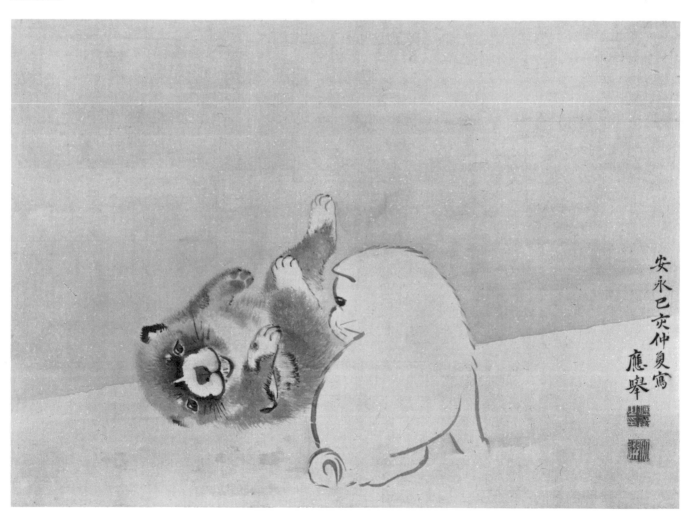

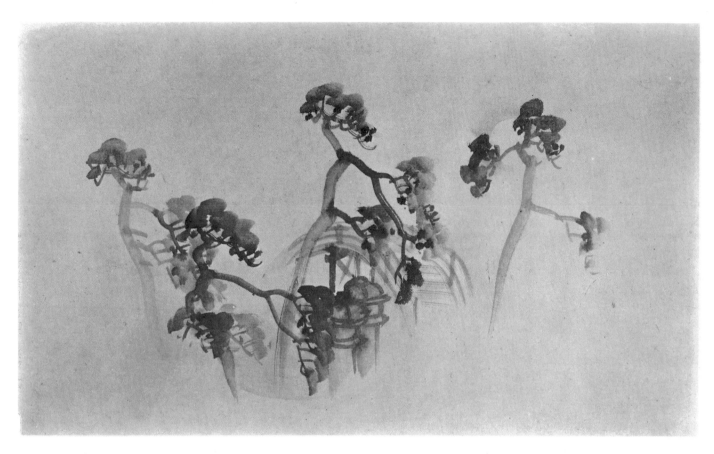

Plate 23

Suzuki NANREI • *Pines and drum bridge, moonlight, c.1830* • ink and slight color on paper, 10¾ x 15 inches • J. R. Hillier, Redhill, Surrey, England

Plate 24

Suzuki NANREI • *Village at the edge of the sea* (from an album), c.1830 • ink and color on paper, 10¾ x 15½ inches • J. R. Hillier, Redhill, Surrey, England

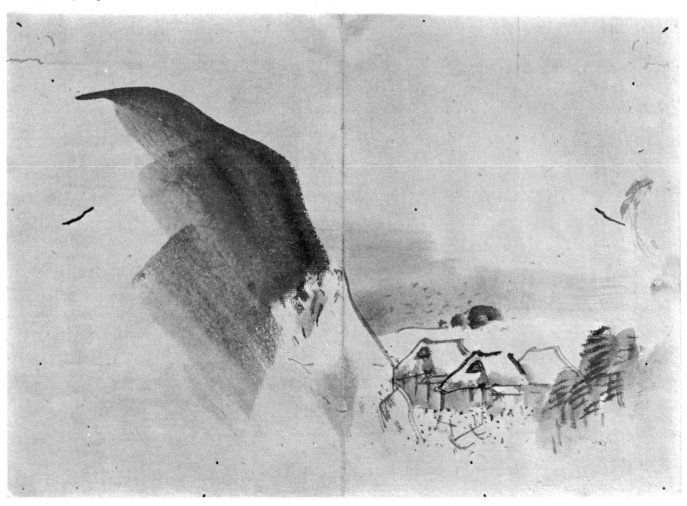

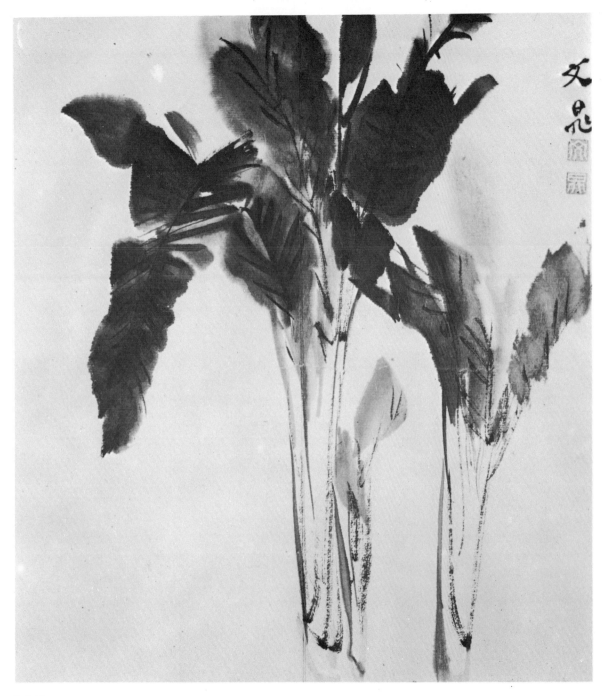

Plate 25

Tani BUNCHO • *Banana leaves (from an album)* • ink on paper, 9-13/16 x 10-15/16 inches • British Museum, London

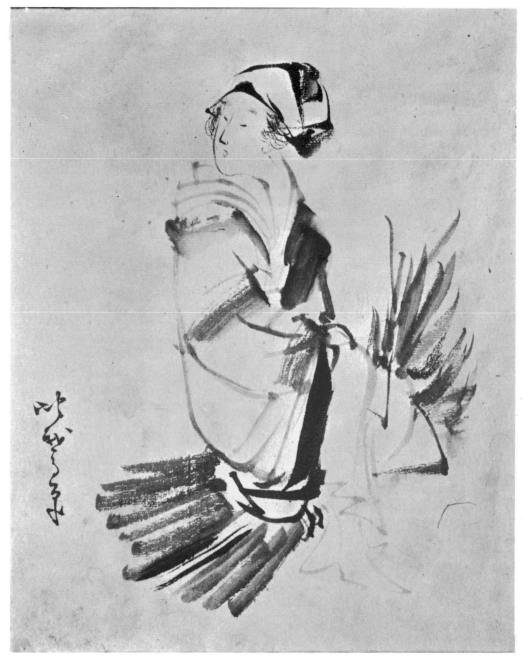

Plate 26

Katsushika HOKUSAI • *O-harami girl (faggot seller)* • ink on paper • Ralph Harari, London

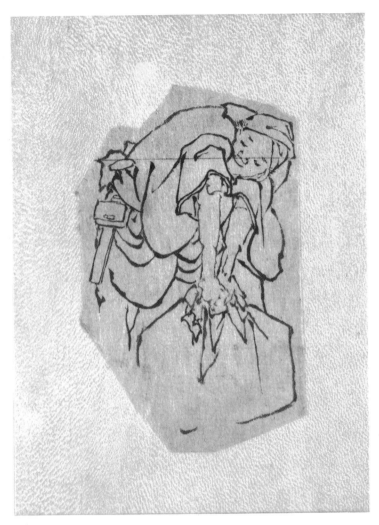

Plate 27

Katsushika HOKUSAI • *The Porter* • ink on paper, 3½ x 2¼ inches
Mme. Huguette Berès, Paris

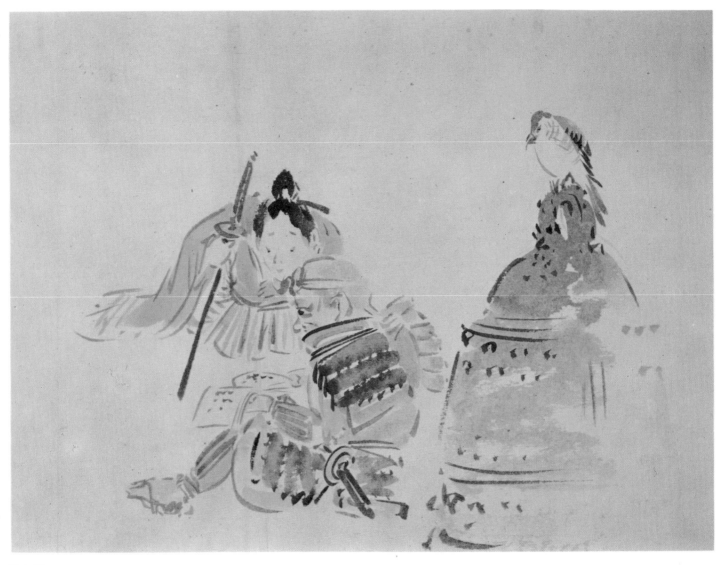

Plate 28

Shibata ZESHIN • *Benkei and the Great Bell* (section from a *makimono*) • colors on paper, 10½ inches high •
Ralph Harari, London

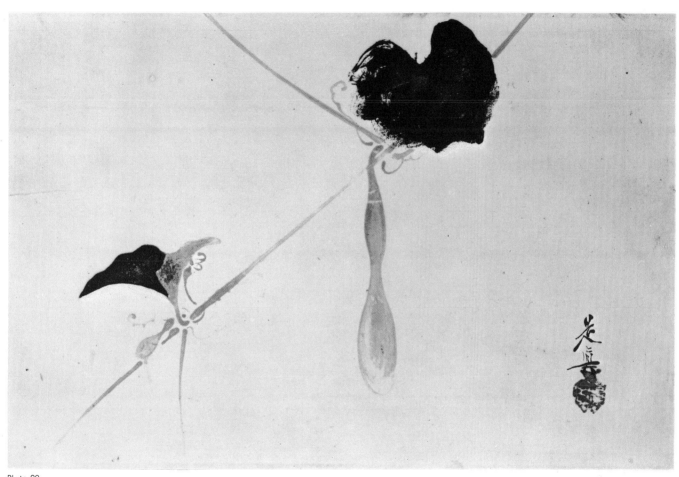

Plate 29

Shibata ZESHIN • *Gourd* • lacquer on paper • Ralph Harris, Otford, Kent, England

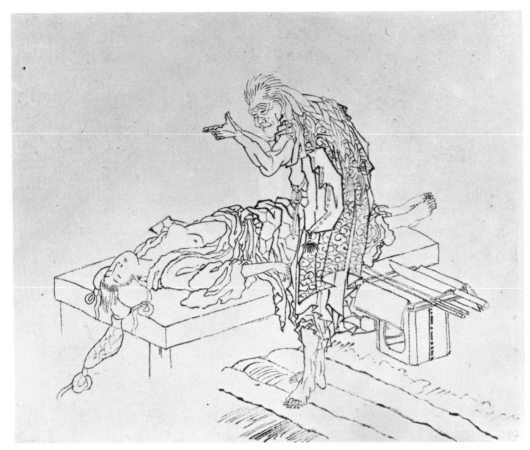

Plate 30

Katsushika HOKUSAI • *Old hag menacing a girl on a bench* • ink on paper • Ralph Harari, London

Plate 31

Matsumura GOSHUN · *Fukurokujū, the God of Longevity, c.1800* · ink on paper, 12¼ x 15¾ inches · J. R. Hillier, Redhill, Surrey, England

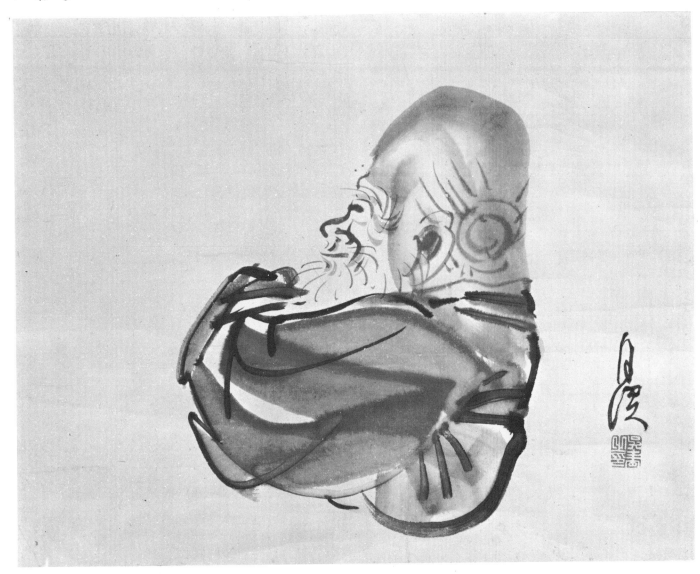

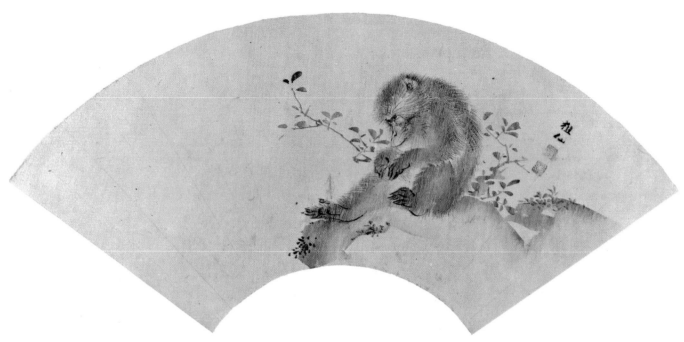

Plate 32

Mori SOSEN • *Monkey (from a fan)* • color on paper • Ralph Harari, London

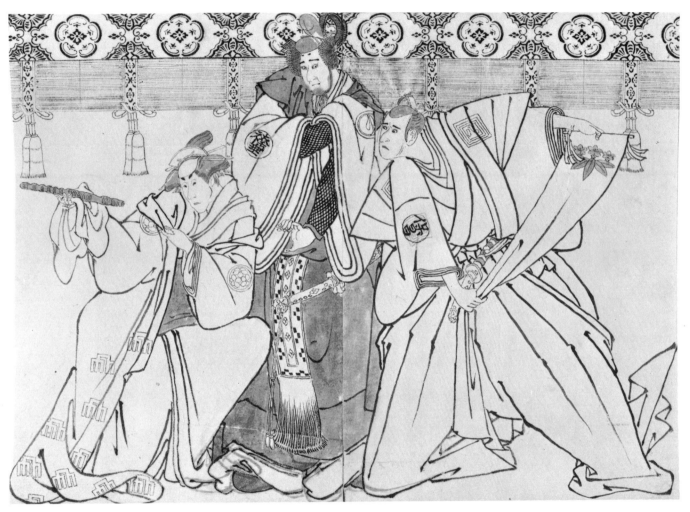

Plate 33

Toshūsai SHARAKU • *Preliminary drawing of Kabuki scene for book illustration*, 1794 • ink and slight color, 8½ x 12 inches •
Museum of Fine Arts, Boston

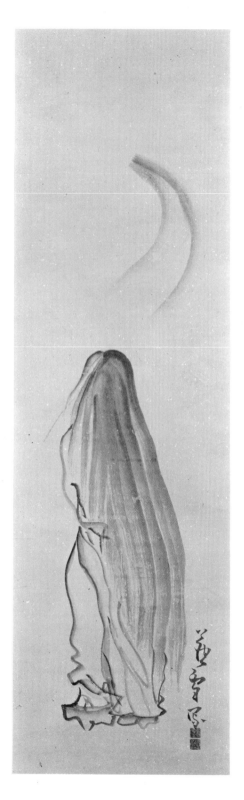

Plate 34

Nagasawa ROSETSU
Shōjō (the red-haired drunkard)
color on paper
Ralph Harari, London

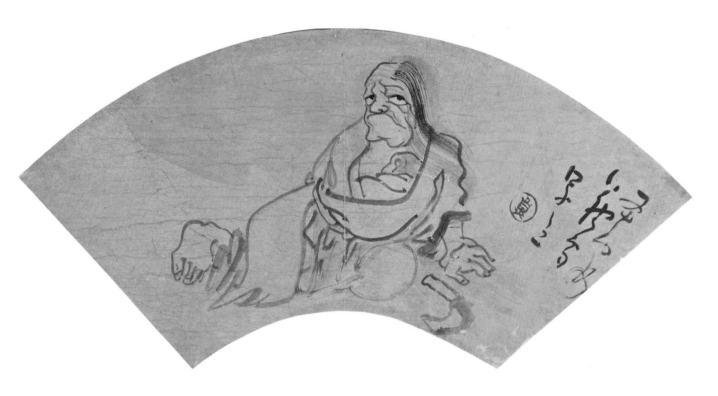

Plate 35

Nagasawa ROSETSU • *Old woman with a child* (fan), c.1810 • ink and slight color on paper, 7⅝ x 18½ inches • J. R. Hillier, Redhill, Surrey, England

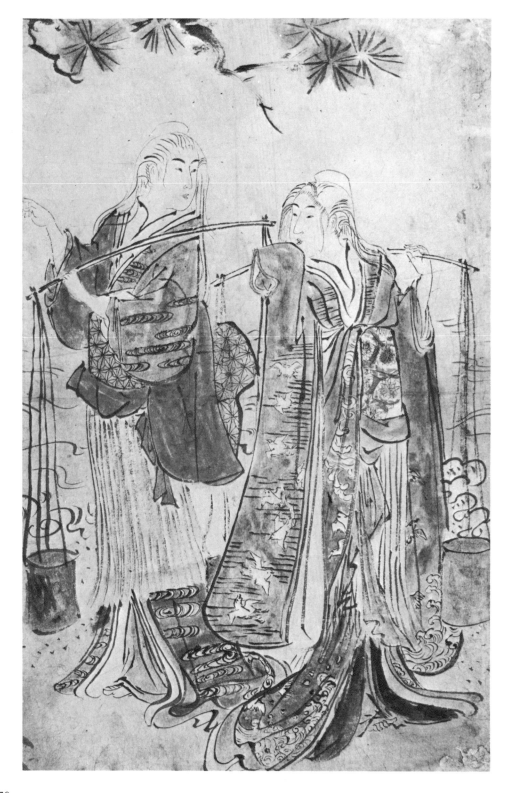

Plate 36

Torii KIYONAGA
*Preparatory drawing for the
color print of Murasame and
Matsukaze*, 1788
ink and slight color on paper,
14¾ x 9⅝ inches
British Museum, London

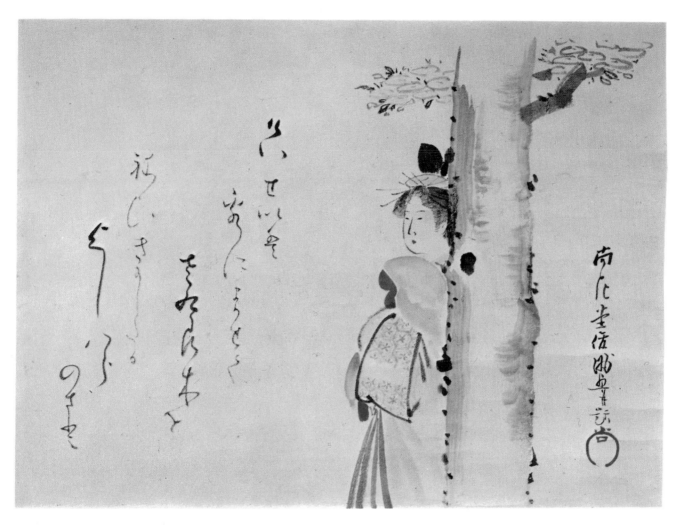

Plate 37

Kubata SHUNMAN · *Girl standing by a tree* · color on paper · Ralph Harari, London

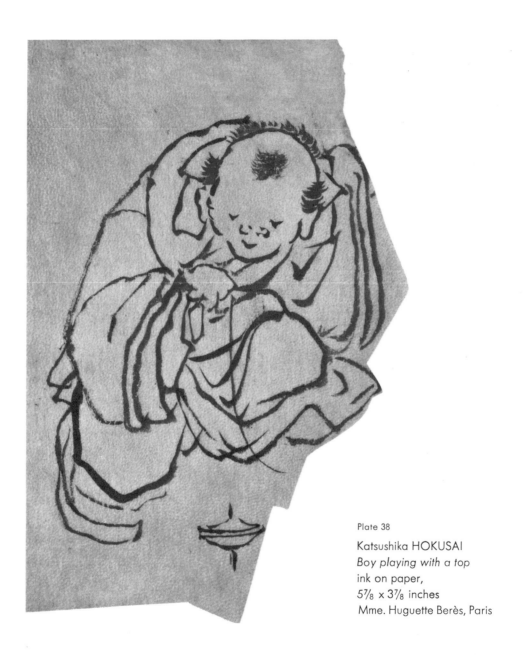

Plate 38

Katsushika HOKUSAI
Boy playing with a top
ink on paper,
$5\frac{7}{8}$ x $3\frac{7}{8}$ inches
Mme. Huguette Berès, Paris

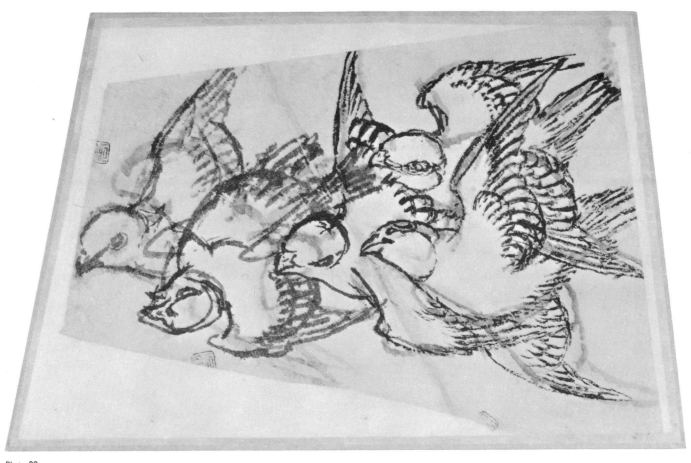

Plate 39

Katsushika HOKUSAI · *Sparrows in flight* · ink and brown tint on paper, 5⅞ x 9 inches · Mme. Janette Ostier, Paris

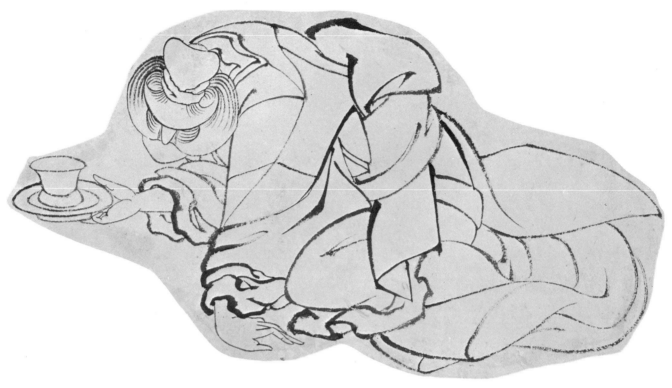

Plate 40

Katsushika HOKUSAI · *Girl offering a cup of tea* · ink on paper, 5½ x 10½ inches · Mme. Janette Ostier, Paris

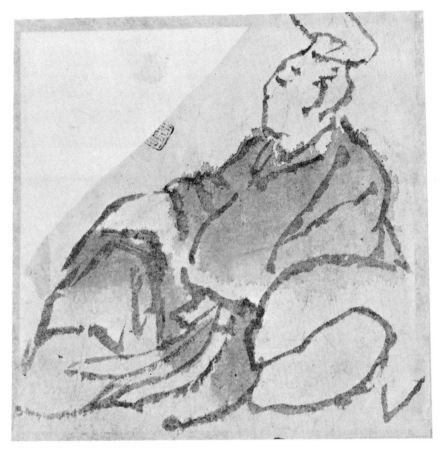

Plate 41

Katsushika HOKUSAI • *Nobleman in eboshi hat, seated* • ink and blue wash on paper, 4½ x 4½ inches • Mme. Janette Ostier, Paris

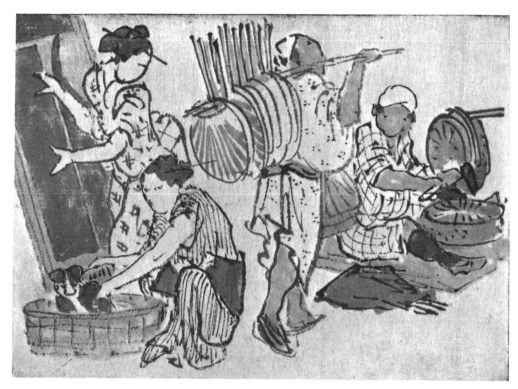

Plate 42

Katsushika HOKUSAI • *Getting ready for the Summer heat* (left sheet from the series known as "Day and Night"), 1832 • ink and color on paper, 3¾ x 5¼ inches • Museum of Fine Arts, Boston

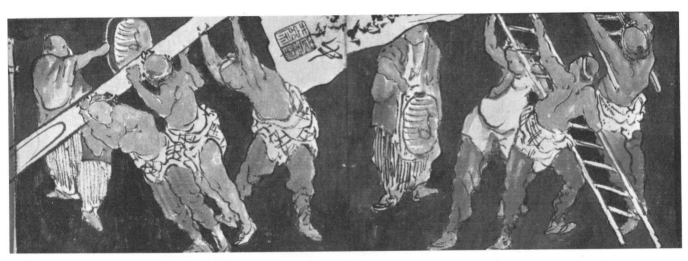

Plate 43

Katsushika HOKUSAI • *Banner Raising* (from the series known as "Day and Night"), 1832 • ink and color on paper, 3⅝ x 10⅜ inches • Museum of Fine Arts, Boston

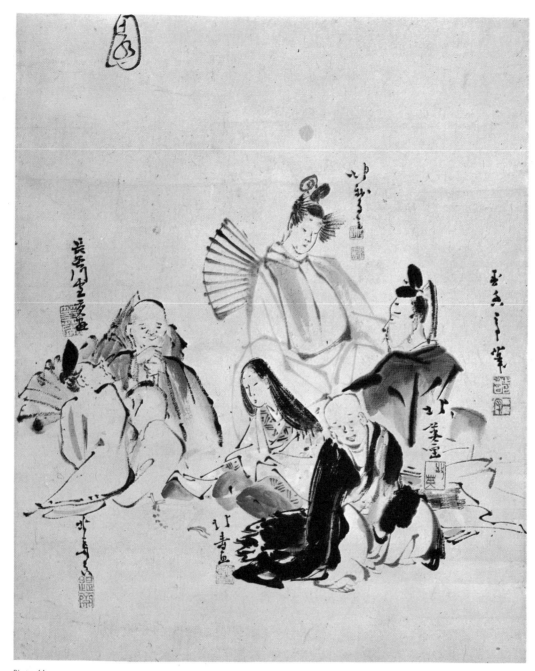

Plate 44

Hokusai Pupils • *The Six Classical Poets, one figure by each of six pupils* • ink and color on paper •
Ralph Harari, London

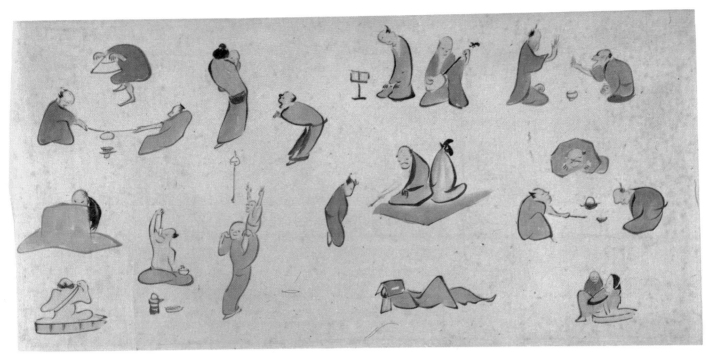

Plate 45

Keisai MASAYOSHI • *Part of a page of studies in the style known as ryakuga (abbreviated drawing)* • ink and color on paper, 11-7/16 x 24½ inches • Rijksmuseum voor Volkenkunde, Leiden

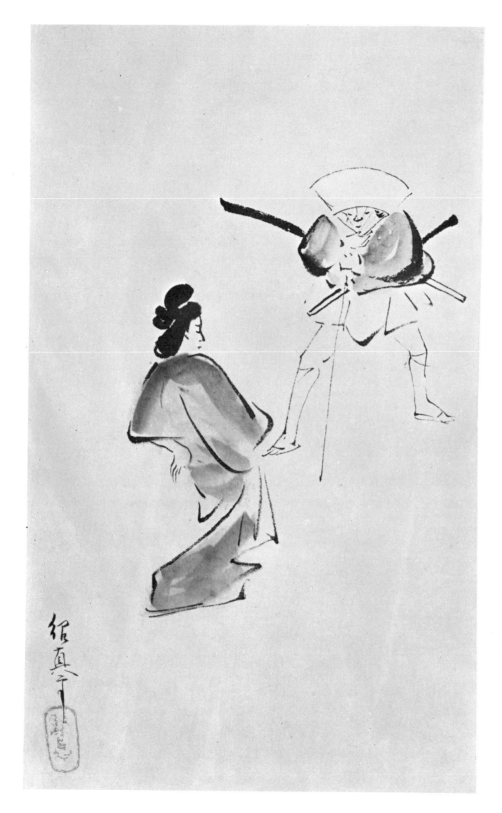

Plate 46

Keisai MASAYOSHI
Courtesan and jester, c.1795
ink and color on paper,
15⅜ x 9⅜ inches
J. R. Hillier, Redhill, Surrey,
England

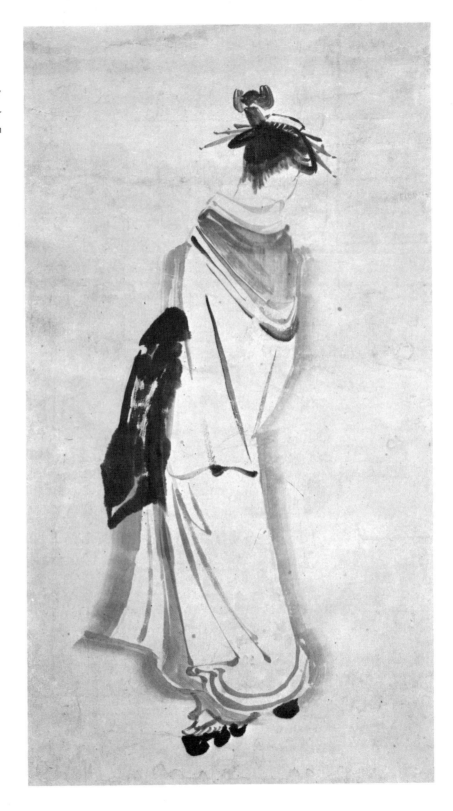

Plate 47

Santō KYODEN · *Courtesan* · color
on paper · Ralph Harari, London

Plate 48

Ichiyūsai KUNIYOSHI
*Sketch for kakemono-e of
Tokiwa Gozen*
ink on paper,
9⅞ x 22-7/16 inches
Rijksmuseum voor Volkenkunde,
Leiden

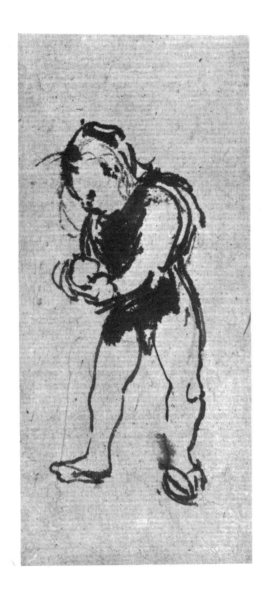

Plate 49

Ichiyūsai KUNIYOSHI
Small boy holding a ball
ink on paper,
5⅝ x 2½ inches
Rijksmuseum voor Volkenkunde,
Leiden

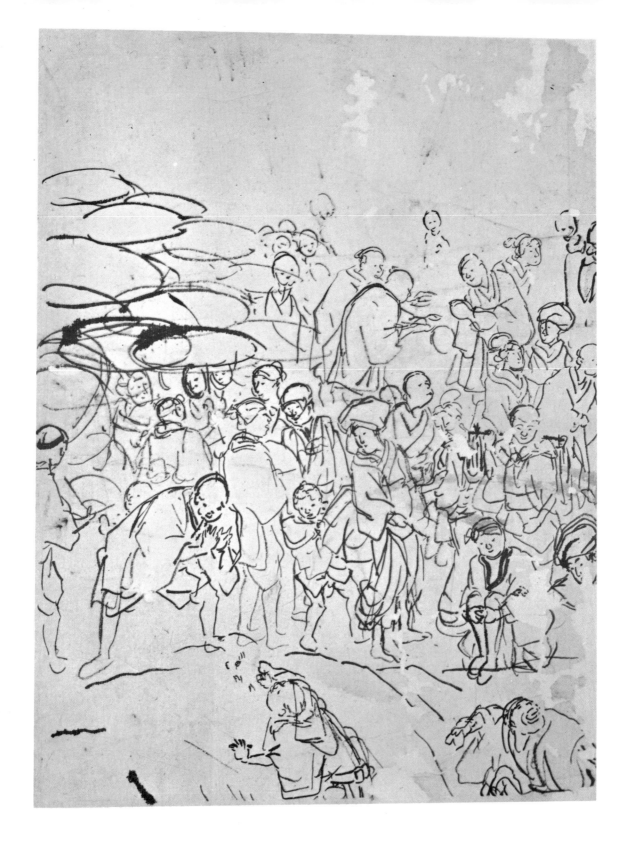

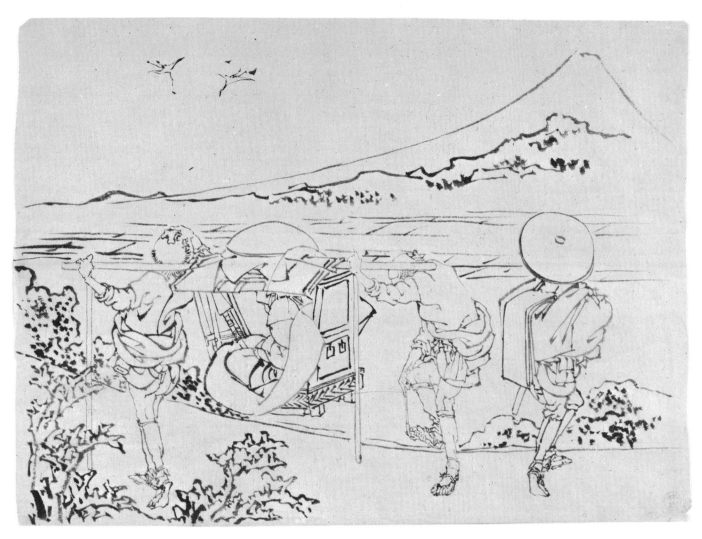

Plate 51
Katsushika HOKUSAI · *Porters carrying a girl in a kago* · ink on paper · Ralph Harari, London

Plate 50

Ichiyūsai KUNIYOSHI
A holiday crowd
ink on paper,
15 x 10-13/16 inches
Rijksmuseum voor Volkenkunde, Leiden

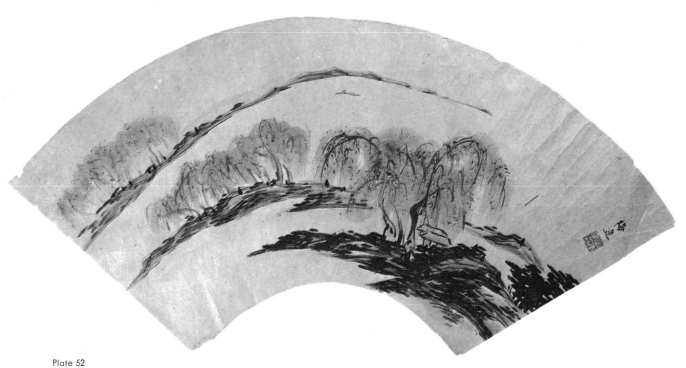

Plate 52

Yamamoto BAI-ITSU • *Willows by a winding stream* (fan), c. 1830-40 • ink and color on paper, 22 x 10⅞ inches •
The Ashmolean Museum, Oxford

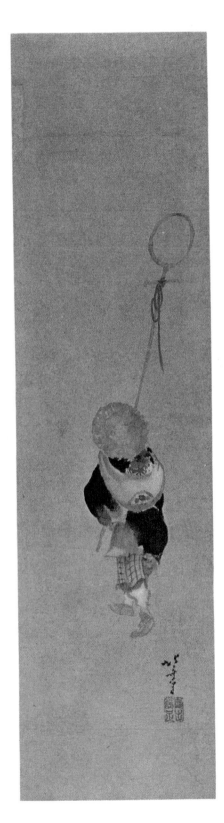

Plate 53

Katsushika HOKUSAI
Monkey-trainer
ink and color on paper
Ralph Harari, London

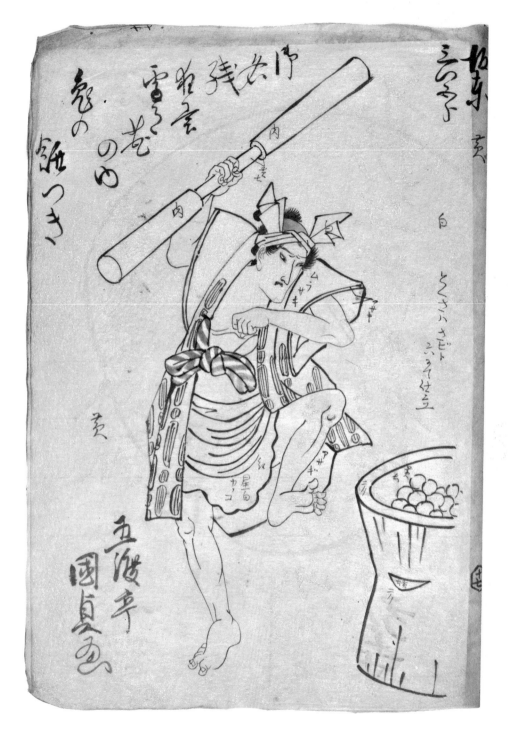

Plate 54

Utagawa KUNISADA
Actor dancing beside mortar with
pestle raised in his hand (preparatory
drawing for color print), c.1840
ink with touches of color on paper,
9⅞ x 13 inches
The Ashmolean Museum, Oxford

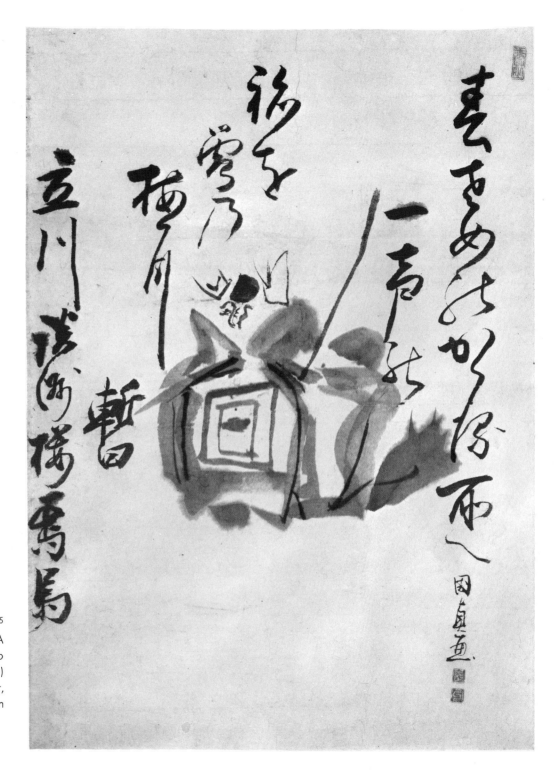

Plate 55
Utagawa KUNISADA
The actor Ichikawa Danjūro
in Shibaraku role (Haiga)
ink and color on paper,
Ralph Harari, London

Plate 56

TSUCHIYAMA • *Riverbank* • Mme. Huguette Berès, Paris

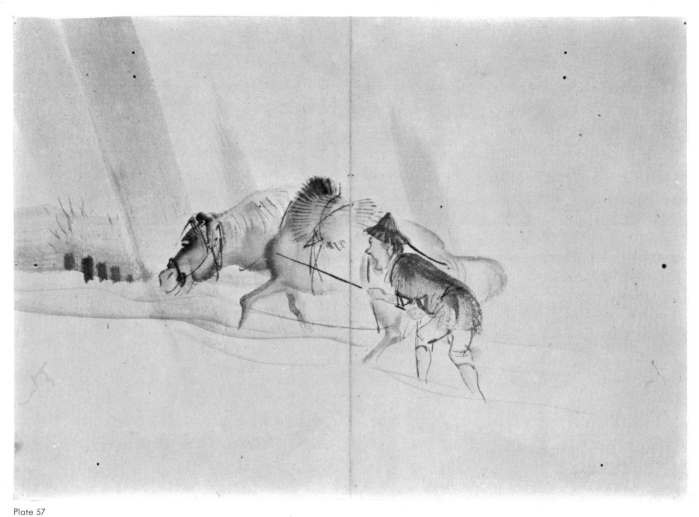

Plate 57

Suzuki NANREI • *Peasant leading a horse in the rain* (from an album), c. 1830 • ink and color on paper, 10¾ x 15½ inches •
J. R. Hillier, Redhill, Surrey, England

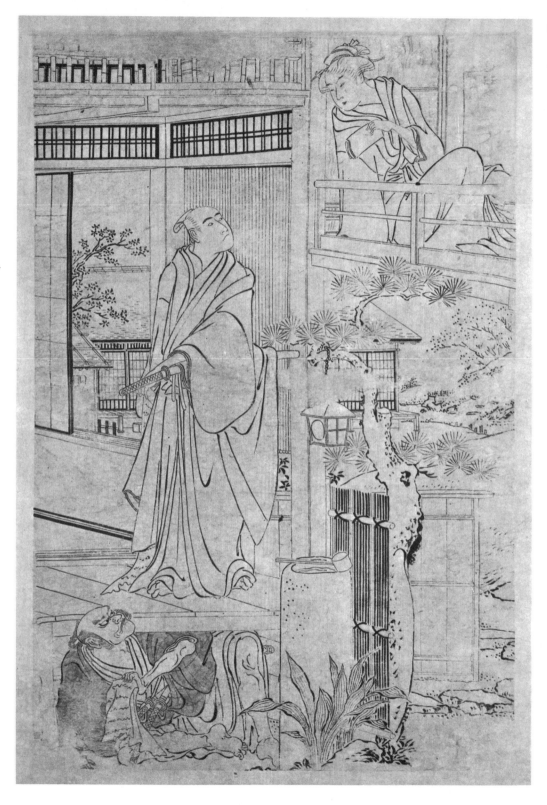

Plate 58
Torii KIYONAGA
Letter-reading scene from the
Chushingura drama (drawing
for color-woodblock print),
1789, ink on paper,
14½ x 9¾ inches
Courtesy of The Art Institute
of Chicago, Oriental
Art Purchase Fund

Plate 59

Attributed to Katsukawa SHUNKO • *Three figures in a Kabuki drama* (actor studies) • ink on paper, 11 x 16⅜ inches •
Rijksmuseum voor Volkenkunde, Leiden

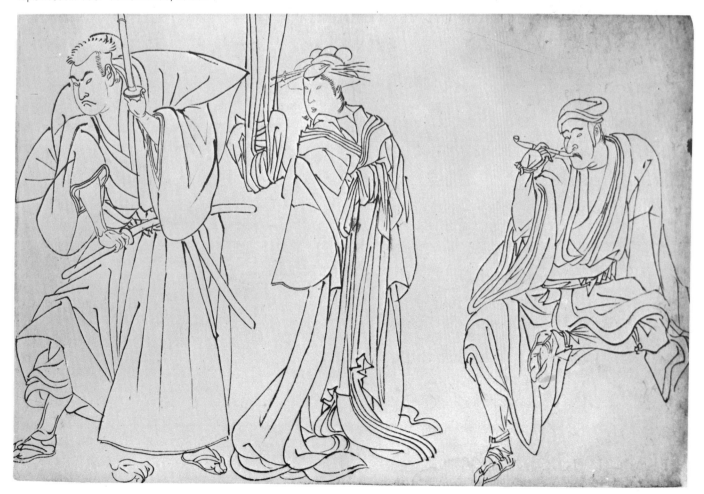

Plate 60
Kawamura BUMPO
Flower-seller
ink and color on paper
Ralph Harari, London

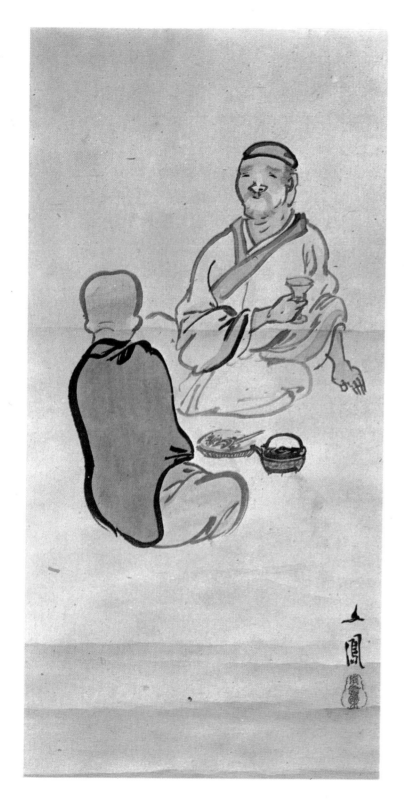

Plate 61

Kawamura BUMPO
Two men drinking together
ink and color on paper
Ralph Harari, London

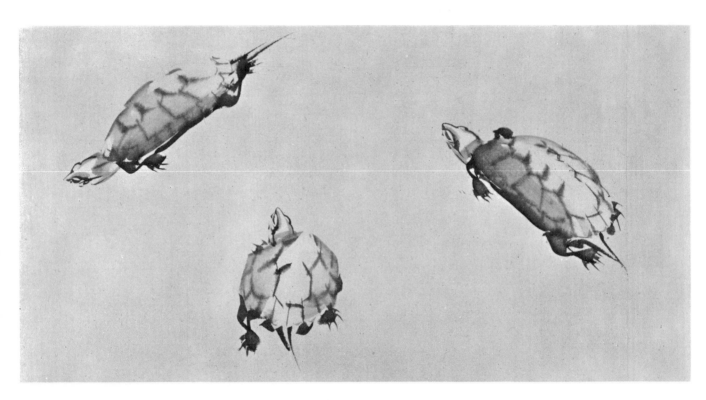

Plate 62

Onishi CHINNEN • *Three turtles* (section from a *makimono*), *1838* • ink and color on paper, 11¼ inches high • J. R. Hillier, Redhill, Surrey, England

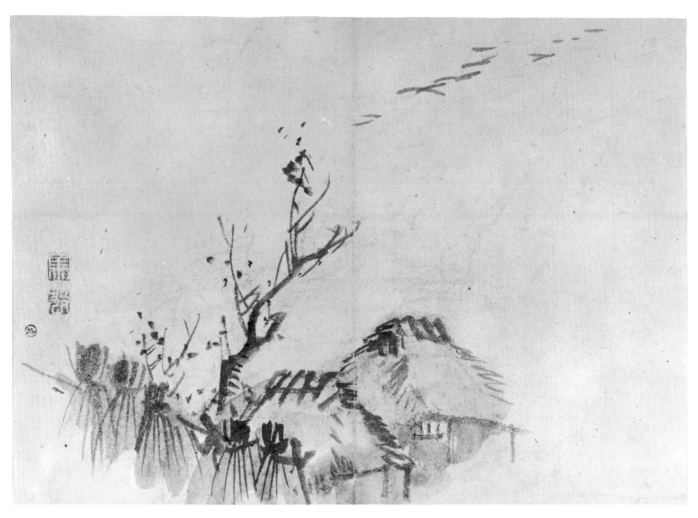

Plate 63

Kōno BAIREI · *Autumn landscape, with birds flying over a cottage* · ink and color on paper, 7½ x 9½ inches · Victoria and Albert Museum, London

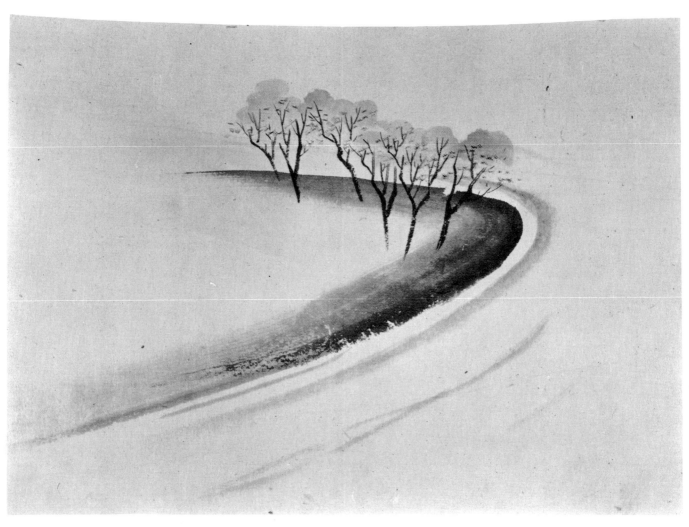

Plate 64

Ichiryūsai HIROSHIGE · *Cherry trees in flower on the bank of a river* · color on paper, 9¼ x 13 inches · Ralph Harari, London

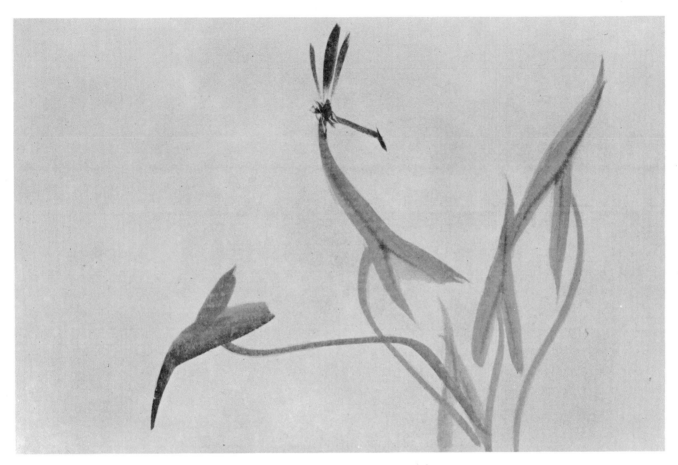

Plate 65

Onishi CHINNEN · *Dragonfly on arrowhead* (section from a *makimono*), 1838 · ink and color on paper, 11¼ inches high ·
J. R. Hillier, Redhill, Surrey, England

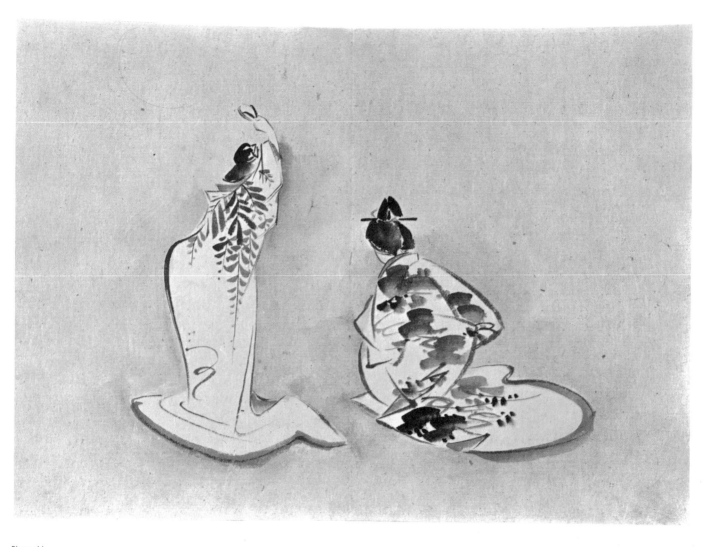

Plate 66

Ichiryūsai HIROSHIGE • *Iwafuji striking Onoe with a sandal* • ink and color on paper, 9¼ x 13 inches • Ralph Harari, London

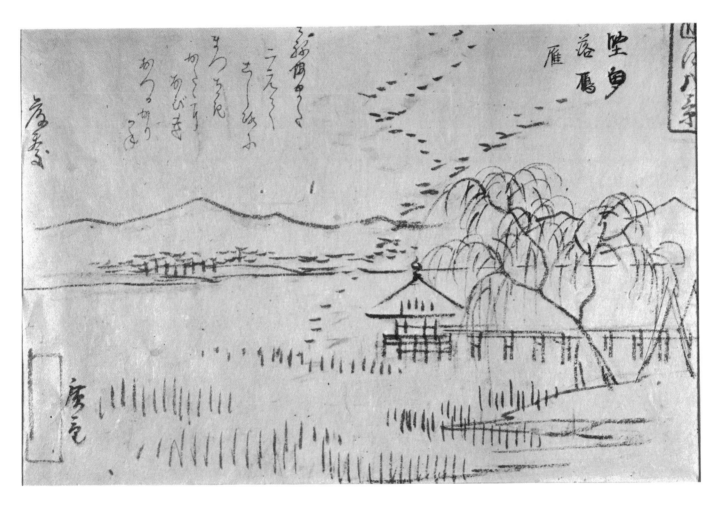

Plate 67

Ichiryūsai HIROSHIGE • *Wild geese alighting at Katata* (study for one of a series of eight color prints, *Omi Hakkei*, the traditional "Eight Views of Omi") • ink on paper, 10 x 15 inches • Mme. Huguette Berès, Paris

Plate 68

Katsushika HOKUSAI • *Chinese farmhouse among trees* • color on paper, 9½ x 10½ inches • Victoria and Albert Museum, London

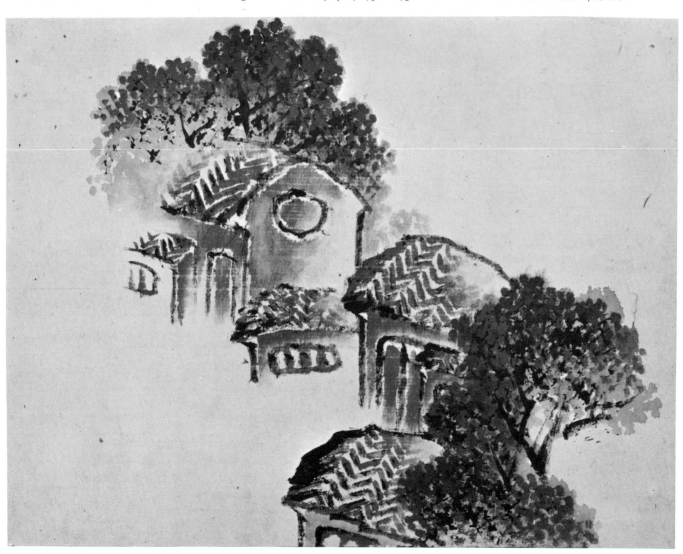

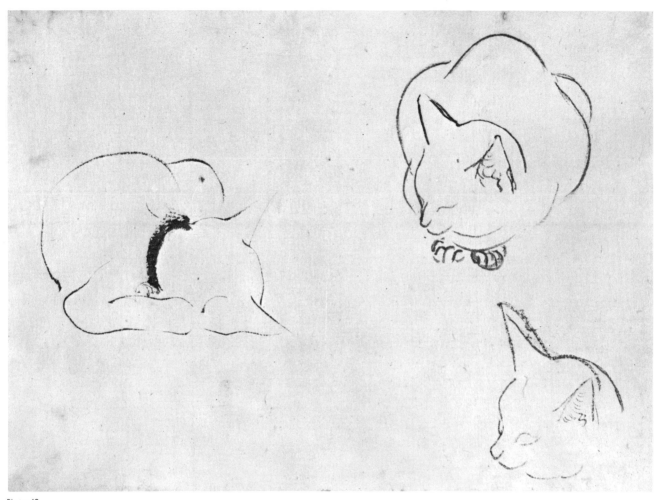

Plate 69

Ichiyūsai KUNIYOSHI • *Three studies of cats* • ink on paper, 9¼ x 12⅞ inches • Rijksmuseum voor Volkenkunde, Leiden

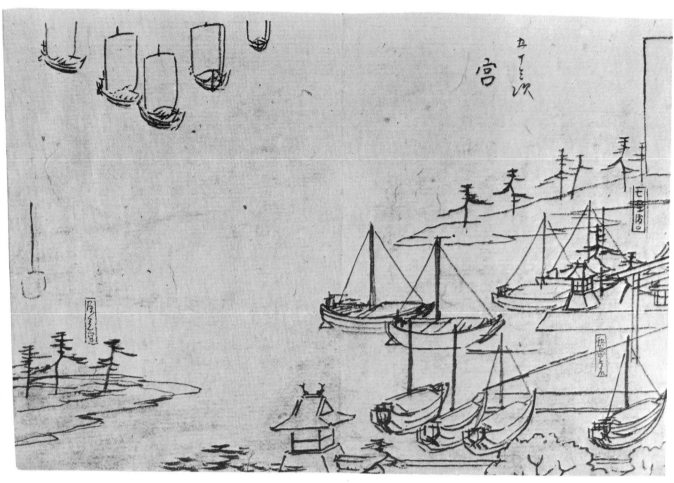

Plate 70

Ichiryūsai HIROSHIGE • *Miya.Craft anchored in a bay* (from an album of 40 preparatory studies for the series of color prints of the Tokaidō) • sumi on paper, 5⅞ x 8⅝ inches • Mme. Huguette Berès, Paris

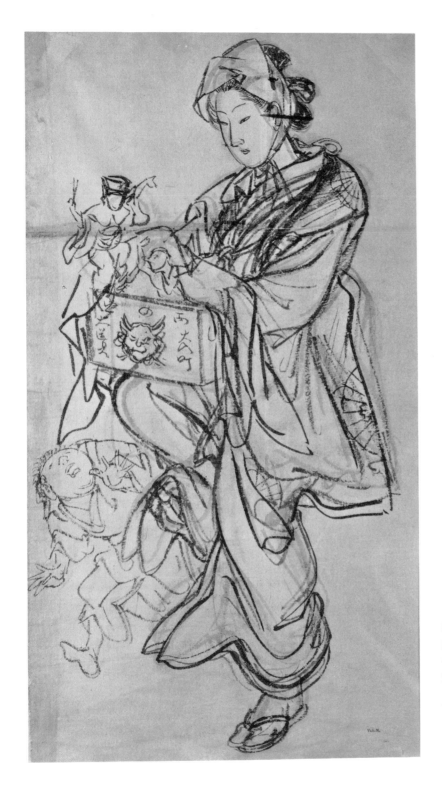

Plate 71

Kawanabe KYOSAI
Girl monkey-trainer
ink on paper,
16⅜ x 9 inches
Victoria and Albert Museum, London

Plate 72

Nonoyama KOZAN • *Three butterflies*, 1818 • color on paper, 4½ x 6⅛ inches • Rijksmuseum voor Volkenkunde, Leiden

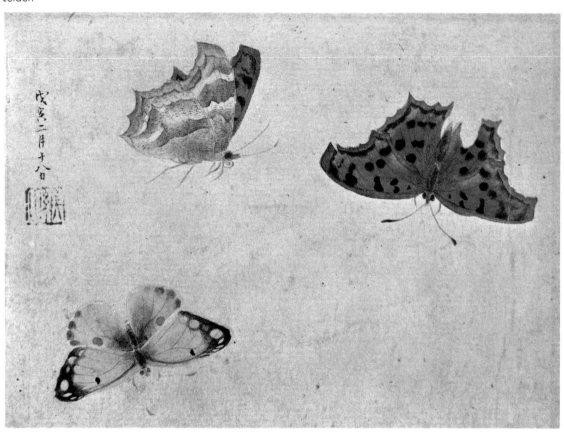

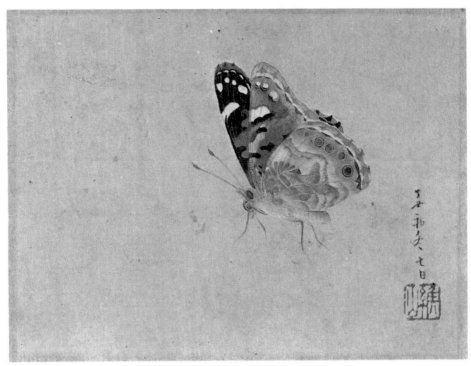

Plate 73

Nonoyama KOZAN • *A single butterfly,* 1817 • color on paper, 3⅞ x 5-1/16 inches •
Rijksmuseum voor Volkenkunde, Leiden

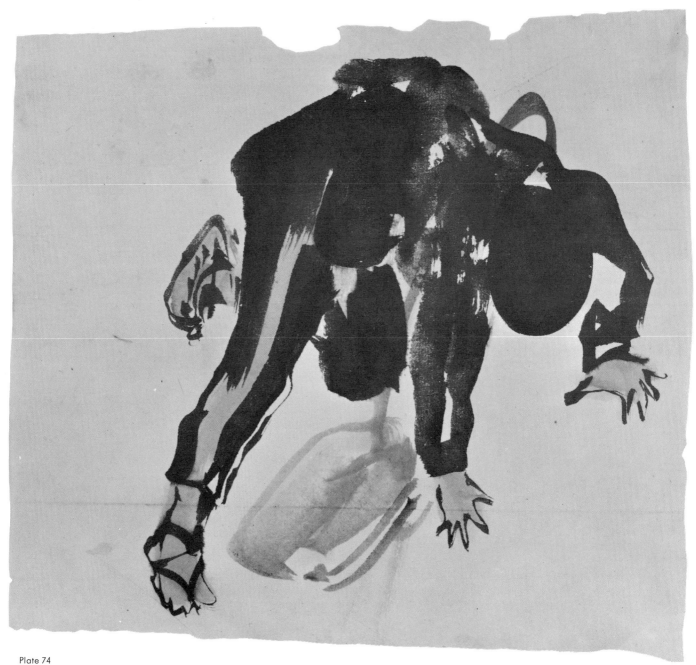

Plate 74

Kawanabe KYOSAI • *Postman falling over his bag* • ink and color on paper, 9-1/16 x 10-7/16 inches • Rijksmuseum voor Volkenkunde, Leiden

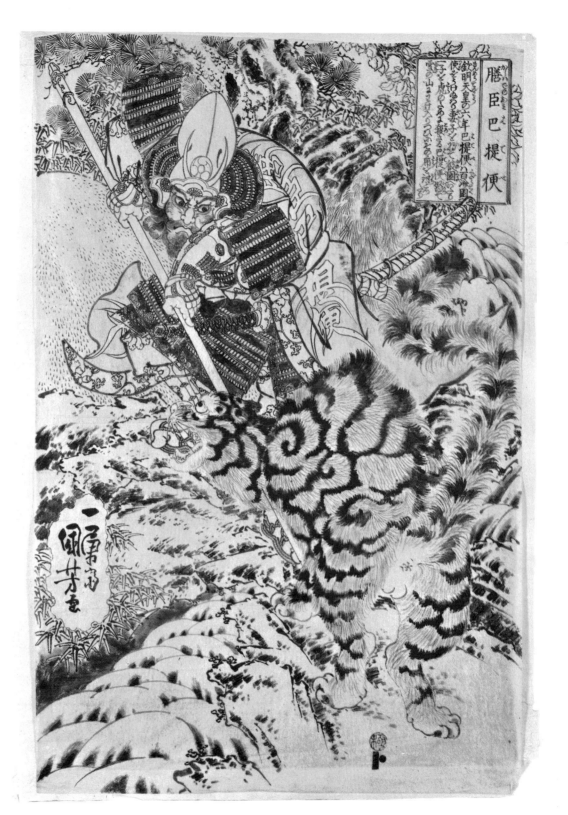

Plate 75
Ichiyūsai KUNIYOSHI
*Kashiwade no Omi Hadesu
killing the Korean tiger that
had carried off his daughter*
ink and color on paper,
15⅝ x 10⅜ inches
Victoria and Albert Museum,
London

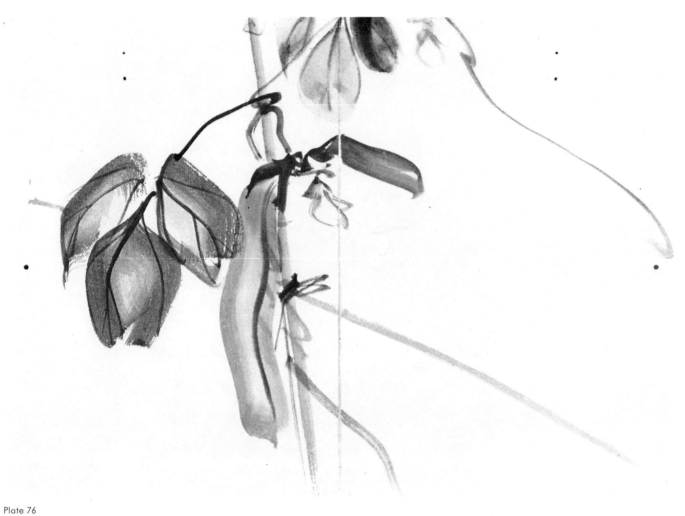

Plate 76

Suzuki NANREI • *Bean pods (from an album)*, c. 1830 • ink and color on paper, 10¾ x 15½ inches •
J. R. Hillier, Redhill, Surrey, England

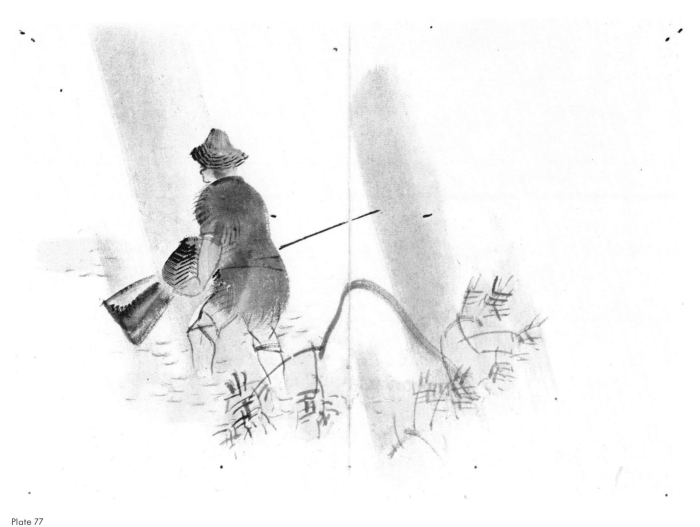

Plate 77

Suzuki NANREI · *Fisherman in the rain* (from an album), c. 1830 · ink and color on paper, 10¾ x 15½ inches ·
J. R. Hillier, Redhill, Surrey, England

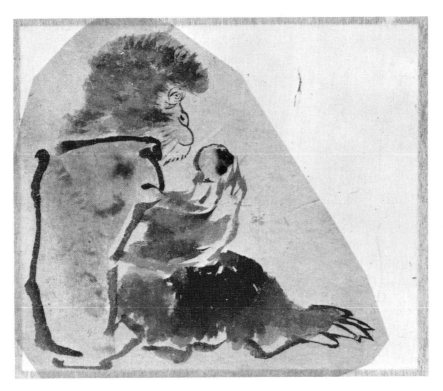

Plate 78

Kawanabe KYOSAI • *Monkey eating a persimmon* • ink and color on paper,
3⅞ x 4-9/16 inches • Rijksmuseum voor Volkenkunde, Leiden

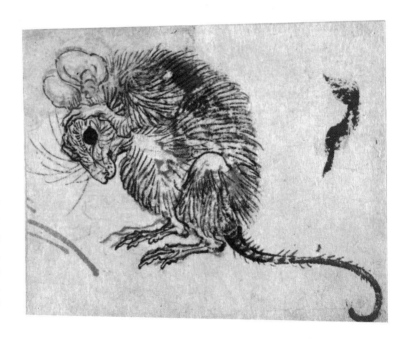

Plate 79
Kawanabe KYOSAI
Mouse washing its head with its paws
ink on paper,
3-3/16 x 3-15/16 inches
Rijksmuseum voor Volkenkunde,
Leiden

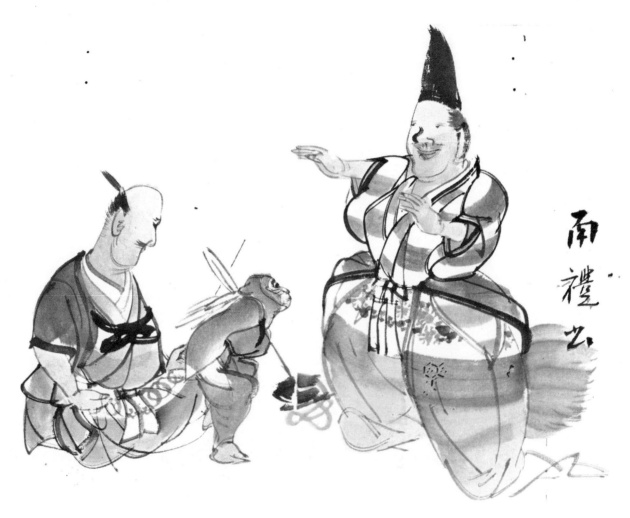

Plate 80

Suzuki NANREI · *Monkey-trainer before nobleman* (from an album), c. 1830 · ink and color on paper, 10¾ x 15½ inches ·
J. R. Hillier, Redhill, Surrey, England

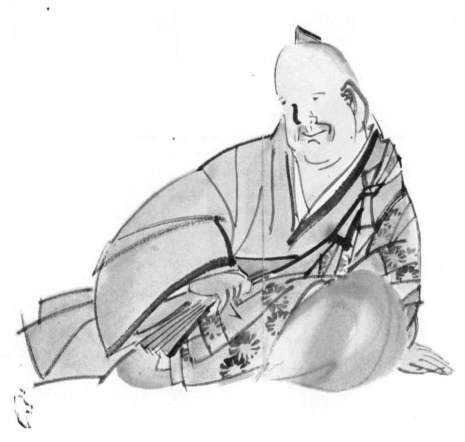

Plate 81

Suzuki NANREI • *Seated old man* (from an album), c. 1830 • ink and color on paper, 10¾ x 15½ inches •
J. R. Hillier, Redhill, Surrey, England

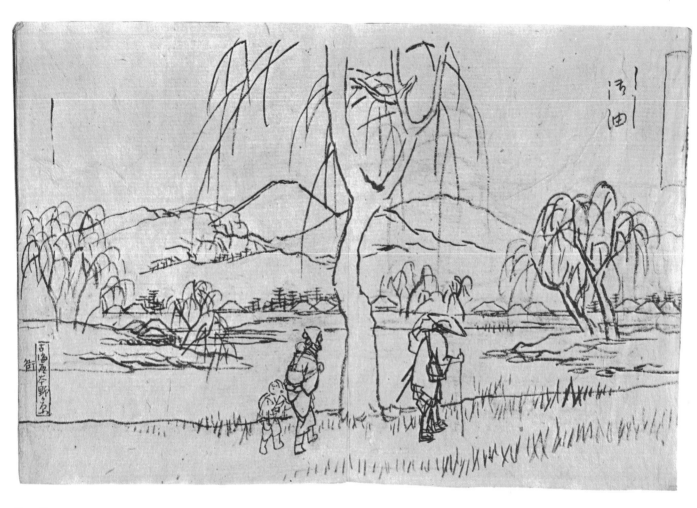

Plate 82

Ichiryūsai HIROSHIGE · *Goyu. Riverbank* (from an album of 40 preparatory studies for the series of color prints of the Tokaidō) · sumi on paper, 5⅞ x 8⅝ inches · Mme. Huguette Berès, Paris

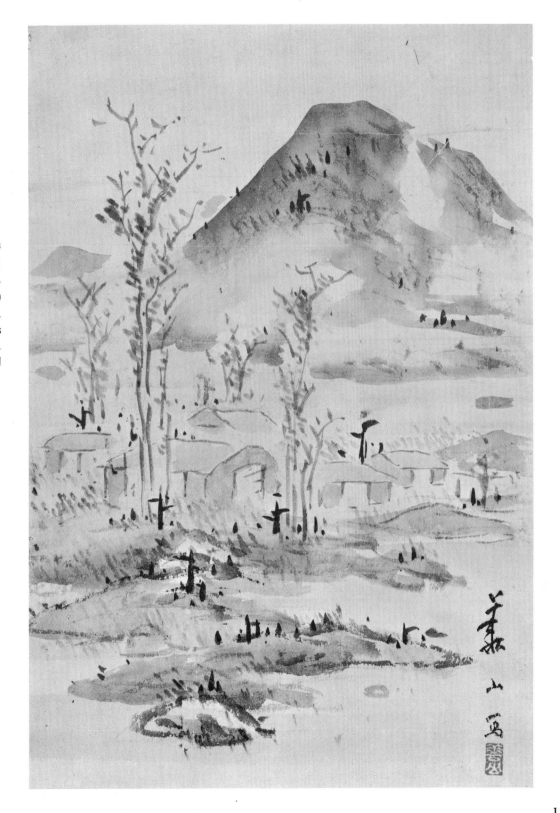

Plate 83

Yokoyama KAZAN
*Autumn landscape with village
below a mountain*, c.1830
ink and color on paper,
15¾ x 1¾ inches
J. R. Hillier, Redhill,
Surrey, England

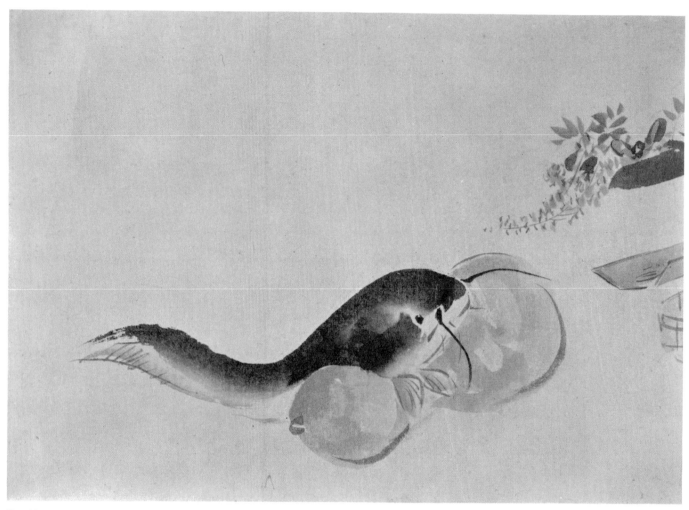

Plate 84

Shibata ZESHIN • *Catfish resting on a gourd* (section from a *makimono*) • colors on paper, 10½ inches high •
Ralph Harari, London

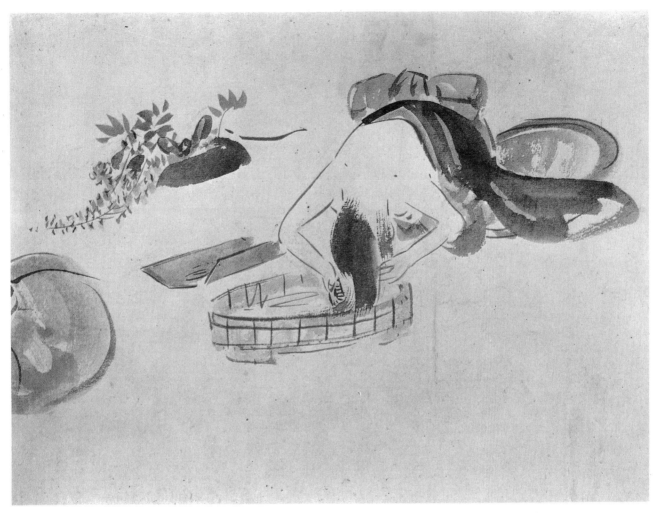

Plate 85

Shibata ZESHIN • *The Wisteria Maiden washing her hair in a tub* (section from a *makimono*) • colors on paper, 10½ inches high •
Ralph Harari, London

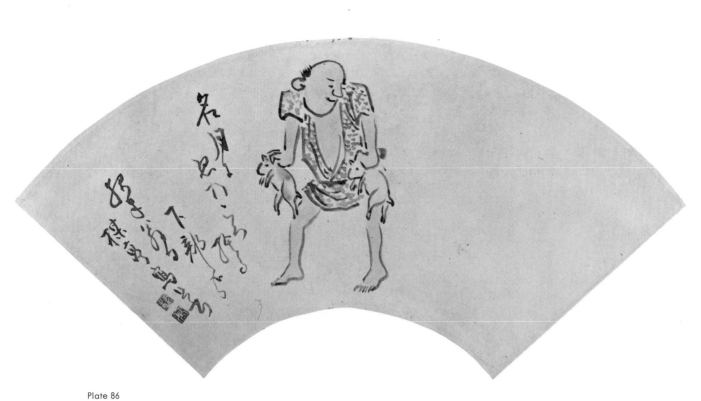

Plate 86

Kyūrō BAITEI • *Peasant with two dead rabbits* (from a fan), c.1810 • ink on paper, 8 x 20 inches • J. R. Hillier, Redhill, Surrey, England

Plate 87

Shōjō SHOKADO • *Hotei* • ink on paper •
Ralph Harari, London

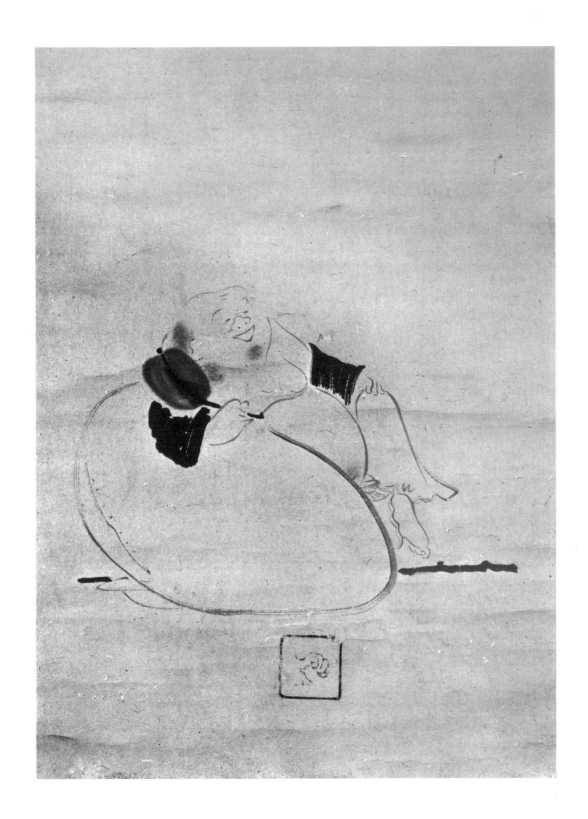

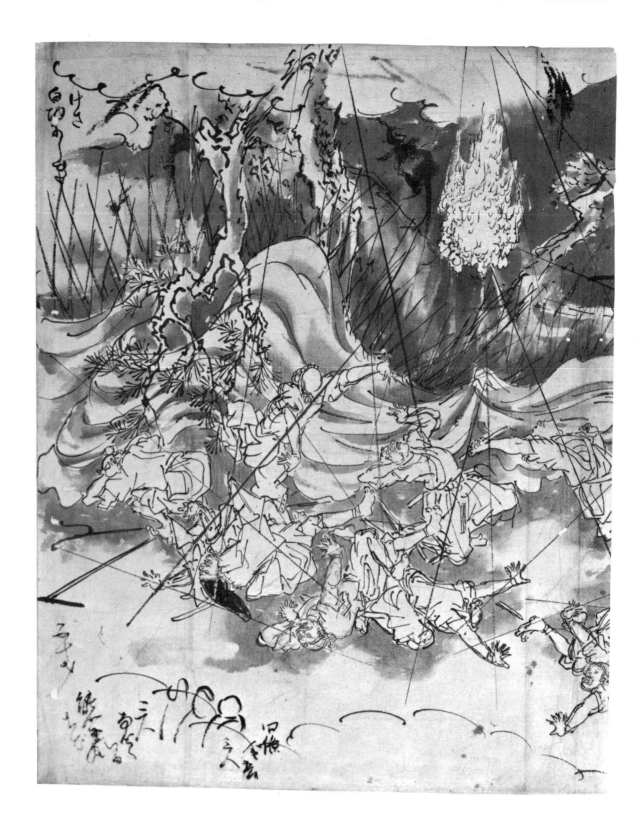

Plate 89

Yosa BUSON • *Self-portrait* (from a letter), c. 1778 • ink on paper, 6-3/4 x 2-7/16 inches • Heinz Brasch, Zurich

Plate 88

Ichiyūsai KUNIYOSHI
Thunderbolt scene (design for
part of a triptych print)
ink on paper,
14-3/16 x 15-9/16 inches
Rijksmuseum voor Volkenkunde,
Leiden

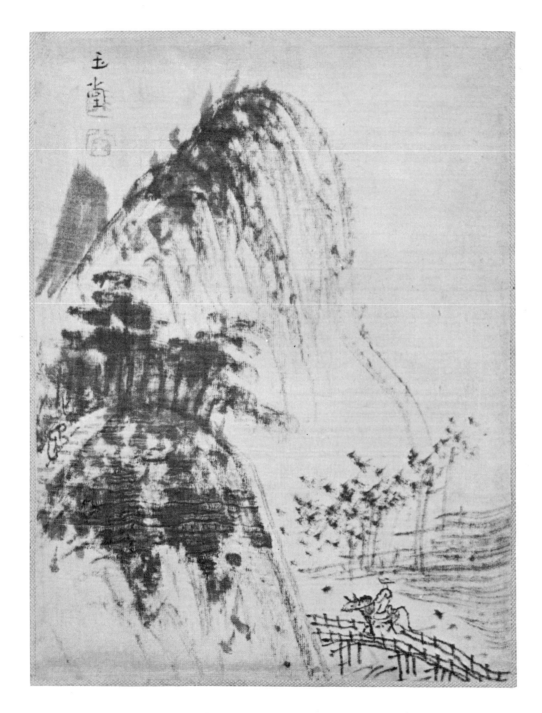

Plate 90

Uragami GYOKUDO
Horseman at a bridge in a valley, c. 1800 • ink on paper, 6⁷⁄₈ x 5¹⁄₄ inches • Heinz Brasch, Zurich

Biographies

Bibliography

Biographies

BAI-ITSU

Yamamoto Bai-Itsu (1783-1856). Although by training and inclination an artist of the Chinese school, he was open to the naturalistic influences of the first half of the nineteenth century, and his work shows a curious blend of styles.

BAIREI

Kōno Bairei (1844-1895). He is known in the West largely through color-printed book illustrations of birds and flowers; these do him less than justice, since they give little notion of his verve and freshness. Grounded in Kanō and developing his individual manner—strongly influenced by Shijō—late in life, he was one of the last of the great Japanese naturalistic painters.

BAITEI

Kyūrō Baitei (1743-1816). *Kyūrō Gafu,* published in 1799 with stark line prints after drawings by Baitei, is one of the most extraordinary books ever produced in Japan. Little is known about the artist, except that he was a pupil of Buson and clearly a master of *Bunjinga.* Few paintings have been recorded.

BUMPO

Kawamura Bumpō (active early nineteenth century). A pupil of Ganku, who was head of a separate sub-school of painting founded on the example of Chin Nampin (a Chinese painter in the Ming tradition who taught in Japan), Bumpō was also deeply affected by both *Bunjinga* and naturalistic influences. His own style is a perfect product of this fusion, and like some hybrids he ends by being classified apart. He was responsible for a number of the most original illustrated books of the classical school.

BUNCHO

Tani Buncho (1763-1840). One of the most notable artists of his day, he was painter to the Tokugawa Court in Edo, instructor to the great families, and master of a considerable number of pupils, including Chikuden and Watanabe Kazan. Originally a pupil of the Chinese school, he became an eclectic and showed skill in a variety of styles, ranging from northern and southern Chinese to the Tosa.

CHINNEN

Onishi Chinnen (1792-1851). A pupil of Nangaku, he became the archetypal Shijō painter at the time of the school's greatest efflorescence in the first half of the nineteenth century. He also used the name Sōnan, and under this name is widely known for the superb album of color-printed designs, *Sōnan Gafu*. Zeshin was one of his pupils.

GOSHUN

Matsumura Goshun (1752-1811). One of the greatest of later Japanese artists, able more than most to fire naturalism with poetic mood. Originally using the name Gekkei, he had his first real training as a painter with Buson, from whom he learned *Bunjinga*. Later, after an association with Ōkyō, who gave him a bias towards naturalism, he founded his own school (named "Shijō"—Fourth Street—after the location of his studio) which became possibly the paramount influence in nineteenth-century Japanese art.

HAKUIN

Ekaku Hakuin (1685-1769). Forsaking the world at the age of fifteen, Hakuin sought enlightenment from various monks, finally finding his salvation in the

Zen religion. He became one of the most influential forces of the sect; it was said of him that only one such as he appeared in each 500 years. In his painting, he used satire and humor to convey the hard spiritual lessons of the cult.

HANKO

Okada Hankō (1795-1845). Pupil of Watanabe Kazan, he became one of the most dedicated artists of the Chinese school of the first half of the nineteenth century. Noted for the subtlety of his ink painting, he was more tied to a strictly Chinese manner than either Kazan or Chinzan. Nevertheless, he appears at times to ape or parody certain of the early Chinese masters.

HIROSHIGE

Ichiryūsai Hiroshige (1797-1858). A member of the Utagawa sub-school of Ukiyo-e and originally a pupil of Toyohiro, he quite early found his bent as a designer of landscape prints. His first and greatest set of the Tokaidō appeared in the early 1830's. He was, even by Ukiyo-e standards, a prolific artist, responsible for thousands of prints. Of the many brush drawings that have survived, two distinct types are apparent: outline sketches, often made from nature, as preparation for color prints; and others where the artist had no other end in view than the drawing itself. In these latter, he used a broad brush line and transparent washes, in a style very much akin to that of the Shijō masters.

HOKKEI

Totoya Hokkei (1780-1850). He studied first under a Kanō master, Yosen-in, but quite early placed himself under Hokusai; he is perhaps the best known of the latter's pupils. He is widely known for his skill as a designer of *surimono,* the elaborate little prints of congratulation, good wishes, or announcement.

HOKUBA

Teisai Hokuba (1770-1844) . Usually accounted the most original of Hokusai's pupils, Hokuba is known not by his prints, which are relatively few in number and mostly *surimono,* but by his paintings. These often vie with those of his master, though in a perfectly distinguishable style.

HOKUSAI

Katsushika Hokusai (1760-1849) . Originally a pupil of the Ukiyo-e master Shunshō, he was in his early manhood a designer of books and prints typical of that school. He is more widely known for prints—such as the *Thirty-six Views of Fuji, Waterfalls, Bridges,* the two *Flower* sets, and the *Poetry of China and Japan*—which often transcend the school style and belong to a realm of their own. *The Wave,* to take the best-known example, is probably the most universally admired of all the prints produced by man. Hokusai "lived with a brush in his hand" and thousands of drawings are extant; not all are good, and not all are accepted as his, but among them are sufficient to ensure his place as one of the great draughtsmen of the world, with a faculty to impart life that makes us forget his shortcomings.

HYAKUSEN

Sakaki Hyakusen (1698-1753) . Born in Nagoya, son of an apothecary with Chinese interests, he later settled in Kyoto. He became one of the earliest *Nanga* artists (using *"Nanga"* in the sense of the later, eighteenth-century Chinese school) , and introduced Buson to the style. Like a number of painters of this persuasion, Hyakusen was also a *haiku* poet of note.

ITCHO

Hanbusa Itcho (1652-1724) . One of the great geniuses of Japanese painting,

he was a humorist with an originality and skill unusual even in Japan. A member of the Kanō school, he eventually found his own individual style— a blend of Kanō, Tosa, and Ukiyo-e. In middle life he fell foul of the Bakufu, the government of the day, and was banished to the island of Miyake, where he was allowed to continue painting. He has the reputation of having been a great *bon viveur*.

KAZAN
Watanabe Kazan (1792-1841). Revered today as one of the great patriots of his country, Kazan was also one of the outstanding Chinese-school artists; unlike many of the school, he remained a keen observer of nature. Because of his interest in Western philosophy and science, his work—especially in portraiture—shows tendencies towards Westernism, but his most typical paintings are *Bunjinga*. He was obliged to commit *seppuku*, largely as a result of his being before his time in proposing that Japan should be opened up to foreigners. His life is one of the saddest in the annals of Japanese art, but his art among the most serene.

KEIBUN
Matsumura Keibun (1779-1843). The younger brother of Goshun, Keibun was, with Toyohiko, at the head of the Shijō school from Goshun's death in 1818 until his own in 1843. He developed the more purely naturalistic side of the school style and is renowned for his paintings of birds, flowers, and pine trees. He is also a major landscapist and designer of *surimono*.

KIYONAGA
Torii Kiyonaga (1752-1815). Head of the fourth generation of the Torii family of Kabuki-print designers, Kiyonaga was the leading Ukiyo-e designer

of the 1780's and indeed is looked upon by some as the culminating figure of the whole print movement. He was a master with great suavity of line and dignity of composition, and the creator of what his biographer, Chie Hirano, calls a "noble, pure and healthy type of female figure."

KŌRIN
Ogata Kōrin (1658-1716). Kōrin is one of the great decorative artists of Japan, and is known for his work in such varied media as painting, lacquer, pottery, and even kimonos. Although trained first under a Kanō artist, he became the artistic heir to Sōtatsu and Kōetsu, and developed a strain of stylized patterning of plants and animals that was entirely his own. He exemplifies the rich extravagance of the Genroku era (1688-1712).

KŌZAN
Nonoyama Kōzan (active early nineteenth century). Little seems to be known of this artist. He was clearly a poet as well as a naturalist, and his work was evidently appreciated in cultured circles.

KUNISADA
Utagawa Kunisada (1786-1864). After Toyokuni's death, Kunisada was virtually the leader of the Utagawa sub-school of Ukiyo-e. He carried on the tradition of theatrical color-print designing with an output that would impair the artistry of any artist, however resourceful. He was, in fact, an artist of high ability, and some prints and paintings reveal a power which the bulk of his work would not lead one to suspect.

KUNIYOSHI
Ichiyūsai Kuniyoshi (1797-1861). Another pupil of Toyokuni, Kuniyoshi was one of the most gifted and fecund artists of the Ukiyo-e school in the nine-

teenth century, with an output as extensive as that of Kunisada. His prints of actors are the least interesting of his work, but he is supreme in landscape—to which he devoted a few sets of prints—and in triptychs based on the epic events of Japanese history. Many of his prints show an awareness of European art, and a few are based directly on Western prints.

KYŌDEN

Santō Kyōden (1761-1816). As an artist, he is best known under the name of Kitao Masanobu, with which he signed most of his paintings and prints. After a period of apprenticeship under Shigemasa, he produced striking color prints —including the famous album of seven diptychs of *Autographs of Yoshiwara Beauties* in 1783—that promised a great future in Ukiyo-e. But his gifts as a writer were even greater, or in any case were in greater demand, and he made his reputation as a comic author, turning to painting and print designing only occasionally after about 1790. Like other artists of the "Floating World," he became a tradesman to help support himself, and kept a shop for tobacco pipes, fans, and quack medicines.

KYŌSAI

Kawanabe Kyōsai (1831-1889). When Kyōsai was little more than a boy, he was a pupil of Kuniyoshi, but his main training was with a Kanō artist, Tōhaku. Kyōsai's verve and drollery were not to be confined by the tenets of any one school, and he can be said to have created a style of his own. He is one of those artists around whom a legend of riotous living has accreted, and he is said to have done his best painting under the influence of sake.

MASAYOSHI

Keisai Masayoshi (1761-1824). Extremely versatile and creative, he began his career as a Ukiyo-e artist under Kitao Shigemasa but later veered towards

the classical schools. He is probably best known for his many books illustrated in the style known as *Ryaku-ga shiki,* in which objects and people are rendered in a summary and vivacious way in the fewest possible expressive lines and block-applied colors. Some of his drawings are done in the same style.

NANREI

Suzuki Nanrei (d. 1844). Nanrei, like Chinnen, is the Shijō artist *par excellence.* He owed his initiation to the style to a great early master of the school, Toyohiko, and benefitted also from an association with Nangaku, a follower of Ōkyō. He achieved his best work in the album form, showing to less advantage in the larger format of the *kakemono;* this limitation was common to other painters whose forte was the lyric rather than the narrative or epic.

ŌJŪ

Maruyama Ōjū (1776-1815). An adopted son of Ōkyō, he contributed to an *ehon* as early as 1797, and to an album of Kyōto artists' prints, *Kiejō Gaen,* in 1814. Occasionally, in designs for *surimono* and in album drawings, he shows an uncommon artistic strength.

ŌKYŌ

Maruyama Ōkyō (1733-1795). One of the major Japanese artists, he was a powerful influence on the trend of painting in Japan. A period under a Kanō artist and an admiration for such Chinese masters as Ch'ien Hsüan (1235-1290) —famous for his plant drawing—and Ch'iu Ying (c. 1522- c. 1560) —renowned for his figure drawing—were behind his own naturalistic style. This style was freer and less mannered than that of most of his forerunners; if it was also more materialistic, this reflected the temper of the people of his day. From his style, through Goshun and *Bunjinga,* developed the Shijō style—the most truly national style of the nineteenth century.

ROSETSU

Nagasawa Rosetsu (1755-1799). After Ōkyō, Rosetsu was perhaps the greatest genius of the Maruyama school, with a completely uninhibited brush, a sensitivity to the qualities of line and wash, and a sharp humor manifested in treatment rather than in subject. He was an inveterate nonconformist, in regard to both social etiquette and artistic canons, and his sudden death was thought by some to be due to poisoning by jealous fellow retainers of his lord, the *daimyō*.

SHARAKU

Tōshūsai Sharaku (dates not known). Everybody that reads about Japanese prints knows the incredible story of this artist's sudden emergence in the year 1794 as one of the most powerful of all Ukiyo-e print designers, his 140 prints —all produced in that one year—and his disappearance into impenetrable obscurity thereafter. His accepted drawings are few in number and lack the intensity that makes his prints so compelling; they are, nevertheless, interesting because they were designs for a picture book and, as such, of a different caliber from his broadsheets.

SHICHIKU

Shichiku (active first half of nineteenth century). Although a *haiku* poet of no great pretensions, he was capable, like so many, of the apposite *haiga*.

SHŌKADŌ

Shōjō Shōkadō (1584-1639). Renowned as one of the three great calligraphers of his day, Shōkadō was as independent as an artist can ever be in Japan. With a flair for playing with contrasting tones of ink, and an epigrammatic brevity of expression in his line, his work had the kind of sophisticated decorativeness that reappeared, *mutatis mutandis*, in the work of Ogata Kōrin.

SHUNKŌ

Katsukawa Shunkō (1743-1812). An accomplished follower of Shunshō, he rarely departed from Kabuki subjects and, of all Shunshō's numerous pupils, came closest to the master. Paralysis of his right hand towards the end of the 1780's forced him to design with his left; this may have led to the production of the "large heads" which some claim are his original contribution to the scope of the color print.

SHUNMAN

Kubata Shunman (1757-1820). In the 1780's the all-pervading influence in Ukiyo-e was Kiyonaga, and it is to that artist that Shunman owed his style, rather than to Shigemasa, his first Ukiyo-e master. Unlike other artists who came under Kiyonaga's spell, Shunman remained apart, a refinement and a poetic taste distinguishing him from his comtemporaries. He was a leading *kyōka* poet, and one of the greatest of all *surimono* designers.

SŌSEN

Mori Sōsen (1747-1821). Sōsen was greatly indebted to the new wave of naturalism created by the example of Ōkyō and his followers. As a painter of animals, especially monkeys, he has rarely been excelled. His drawings are sometimes rather more detailed and exact than those of the true Shijō artists, and it is not hard to believe the stories of his hardihood and persistence in perfecting his art through close observation of animals in their wild state.

SŌTATSU

Nonomura Sōtatsu (d. 1643). Although he is now considered one of the world's greatest decorative painters, little is known with certainty of his career. He turned for inspiration to the Yamato-e scrolls of the middle ages, and his

screens repeat their subjects—for example, the Genji Romance and the medieval wars—with a new bigness of design and pattern which is the outcome not merely of his larger format but also of his genius for simplification and for orchestration of large areas of color.

UTAMARO

Kitagawa Utamaro (1753-1806). After Kiyonaga retired, about 1792, Utamaro became the acknowledged leader of Ukiyo-e. He had already designed many prints in a style influenced by Kiyonaga, and had produced some wonderful albums of *Insects, Birds,* and *Shells.* Thereafter his work concentrated more and more on women—women who became more elegant and seductive as the eighteenth century drew to a close. His reputation for profligacy has been challenged by modern Japanese critics, but the evidence of his work undermines their efforts; in any case, this question hardly matters. He was unquestionably the creator of some of the greatest compositions in art, East or West.

ZESHIN

Shibata Zeshin (1817-1891). One of the most distinguished masters of the Shijō school, he is generally recognized as the greatest lacquerer of the nineteenth century. His masters in Shijō painting were apparently Toyohiko and Chinnen. He developed a freedom of expression which only an innate master of the brush could achieve; coupled with this was a rare and subtle attitude that amounts to a sort of wry philosophy, a humor that is only rarely comic.

Bibliography

Aquarelles Japonaises du Dix-neuvième Siècle (exhibition at Palais des Beaux-Arts). Introduction by Georges M. Baltus. Brussels, 1957.

Bowie, Th. *The Drawings of Hokusai.* Bloomington, Indiana, 1964.

Conder, Josiah. *Paintings and Studies by Kawanabe Kyōsai.* Tokyo, 1911.

Gonse, L. *L'Art Japonais.* Paris, 1883.

Japanische Tuschmalerei Nanga und Haiga, aus der Sammlung Heinz Brasch, Zürich (exhibition at Kunstgewerbemuseum). Catalogue and notes by Heinz Brasch. Zurich, 1962.

Loewenstein, Fritz E. *Die Handzeichnungen der Japanischen Holzschnitt-meister. Plauen in Vogtland.* 1922.

Morrison, A. *The Painters of Japan.* London, 1911.

Ouewehande, C. *Japanese Penseel-tekeningen.* Leiden: Rijksmuseum voor Volkenkunde, n.d.

Paine, Robert Treate, and Soper, Alexander. *The Art and Architecture of Japan.* London, 1955.

Poésie de l'instant: Peinture de l'école Shijō, XVIII^e et XIX^e siècles (exhibition at Galerie Janette Ostier). Introduction by J. Hillier. Paris, 1964.

Robinson, B. W. *Drawings by Utagawa Kuniyoshi: Collection of Ferd. Lief-tinck.* Groningen, 1953.

Seikichi, Fujimorei. *On Watanabe-Kazan as a Painter, with particular reference to his sketches and dessins.* Tokyo: Nippon Bunka Chuō Remmei, 1939.

Tomita, Kojirō. *Day and Night in the Four Seasons by Hokusai.* Boston: Museum of Fine Arts, 1957.

Yashiro, Yukio. *2000 Years of Japanese* Art, ed. Peter C. Swann. London, 1958.